A BOOK OF COLORS

Matching Colors
·
Combining Colors
·
Color Designing
·
Color Decorating

Compiled by Shigenobu Kobayashi

Nippon Color & Design Research Institute, Inc.

With the assistance of Ronald Sternberg

KODANSHA INTERNATIONAL
Tokyo and New York

Originally published in 1984 in Japanese as
Haishoku Imeiji Bukku by Kodansha Ltd.

Distributed in the United States by Kodansha International/USA Ltd., through Harper & Row, Publishers, Inc., 10 East 53rd Street, New York, New York 10022.

Published by Kodansha International Ltd., 2-2, Otowa 1-chome, Bunkyo-ku, Tokyo 112 and Kodansha International/USA Ltd., 10 East 53rd Street, New York, New York 10022.

LCC 86-45727
ISBN 0-87011-800-5 (U.S.)
ISBN 4-7700-1300-0 (in Japan)

Contents

How To Use This Book

● Basic

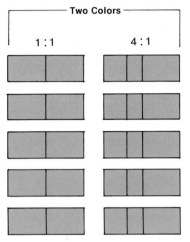

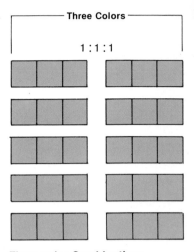

Two-color Combinations

Here various two-color combinations are presented to provide the basic color concept for each section. Pay attention to the differences in tone and shade.

Three-color Combinations

Using the color combinations in the two-color groups, the ten three-color samples here take the basic color concept one step further, by changing proportions and adding different colors.

Personal Image Colors (pp. 6–79)

1. Color models in this section of the book are illustrated in groupings of from two to five colors. The color groups become more complex as you move through the section.

2. Within each four-page section, there are three to five main colors. Note these colors and see how they change depending on how they are grouped together. Also, see how other colors are used to emphasize or highlight these same basic colors. This will help you when you apply these color combinations in practical, concrete situations.

3. An overall view of each section is graphically presented on pages 78–

● Application

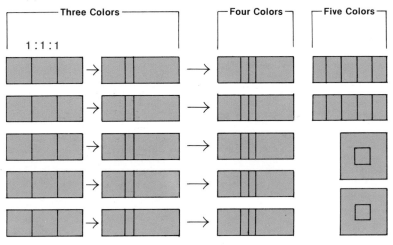

Three Colors — Four Colors — Five Colors

1 : 1 : 1

Alternate Three-color Combinations

Combinations on this page again use the same basic colors as the two- and three-color combinations page, except the proportions have been altered. The ratios of the areas covered by the three colors used are:

1:1:1→2:2:6 1:1:1→2:3:5 1:1:1→3:1:6

Four- and Five-color Combinations

Adding a fourth color and varying the relative proportions in the first column shows how to accentuate the previous three-color combinations. The five-color combinations display the full array of colors in equal proportions.

79. This scale will help you understand the relationships within and between each section.

How to Use Color (pp. 92–127)

1. There are eighteen frequently used colors presented in this section. The left-hand page groups each color in combinations with similar qualities. The right-hand page combinations are much more bold and contrasting.
2. Use these pages to better understand each of the basic colors in relation to other colors.

Fresh

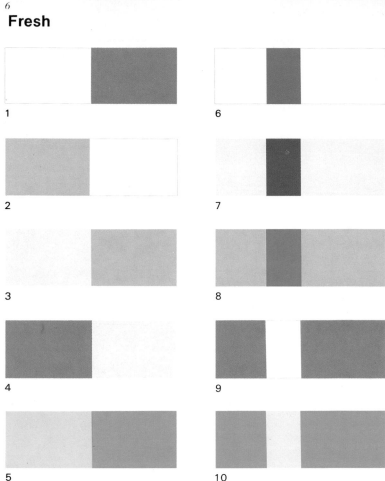

1

6

2

7

3

8

4

9

5

10

Blue is the color of summer skies and cool mountain streams. Use the color combinations on this page to brighten your home and give your wardrobe a cool and refreshing look. Rooms with large windows are naturally appealing using tones such as these.

The addition of white both brightens and lightens color schemes. Refreshing examples can be seen in combinations of blue in 1, peppermint in 2, and green in 6.

Schemes with more than two colors are perfect for spring and summer. Whether dressing for a summer picnic or setting a dinner table,

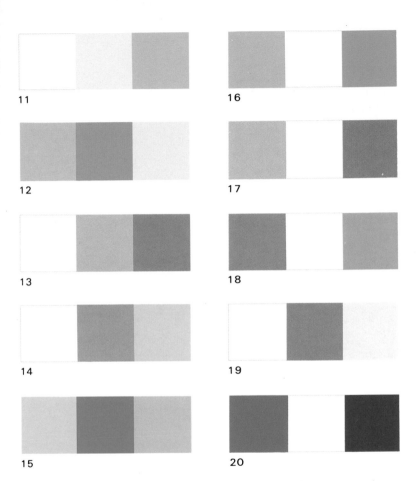

11
16
12
17
13
18
14
19
15
20

three-color combinations such as in 14, 16, 17, and 18 are sure to show you at your best.

See also TURQUOISE (p. 102); SAXON BLUE (p. 104), 2, 3, 4, 8, 9; WHITE (p. 122), 6

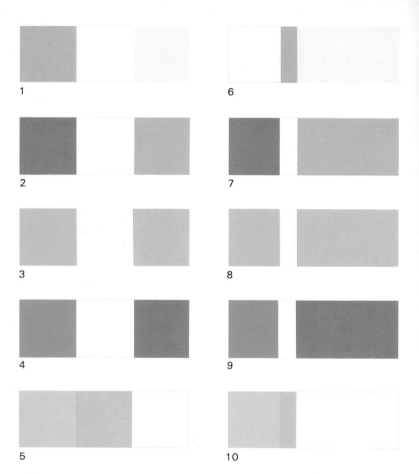

Changing the relative proportions of the blues, greens, and white in this section gives the colors a more vibrant appeal. For example, moving across from 2 to 7 shows how to accent a peppermint-green tablecloth with blue napkins. Adding a swatch of yellow in 12 makes the whole coordination sparkle.

Decreasing the amount of white from 4 to 9 brings out the brightness in the blue and green for a cheerful summery look for your clothes. A dash of pink in 14 adds a feminine touch.

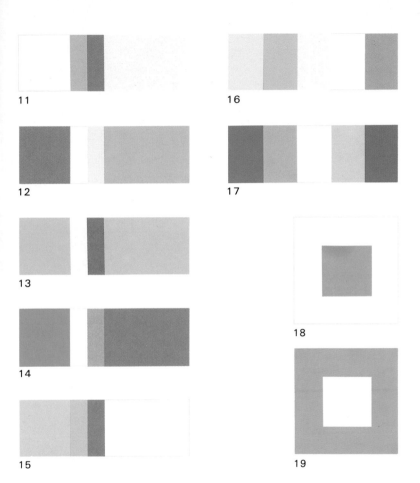

11

12

13

14

15

16

17

18

19

Note in each section the importance of the relative proportion of white to change the balance of the whole coordination.

Youthful

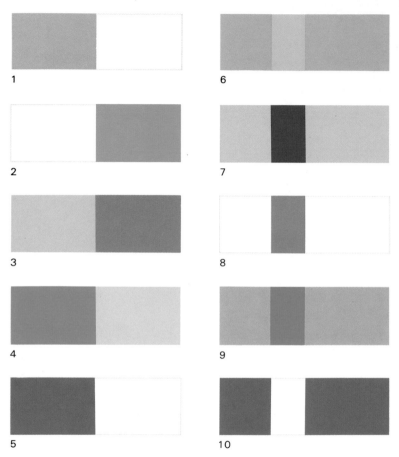

1

2

3

4

5

6

7

8

9

10

Summertime means being outdoors for sports and play. Summertime is also the time for bright and fresh colors in your wardrobe. Get in the mood with combinations of blues, greens, and yellows highlighted by white.

Blues offset with white in 1, 5, and 10 have that sporty and refreshing mood just right for daytime wear, while the greens in 1, 4, 6, and 8 are attractive on tennis courts and golfing greens. Animated shades of yellow contrast with shades of blue and green in 3, 6, and 7 for a fresh and youthful appeal.

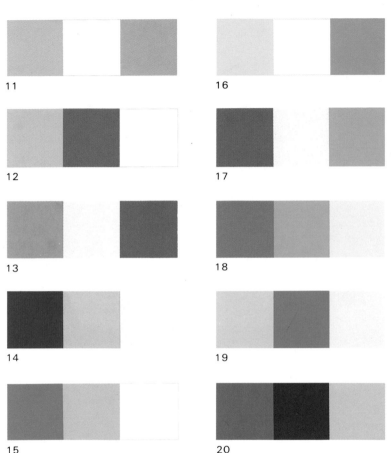

11

16

12

17

13

18

14

19

15

20

The combinations of white, yellow, blue, or green in 11, 15, and 16 have an aquatic quality perfect for days at the lake, while the greens in 17, 18, and 19 beckon one to the country or mountains.

Do not forget these color coordinations when choosing accessories and equipment such as backpacks, sports bags, shoes, rackets, and sunglasses.

See also BLUE (pp. 100–101), 2, 3, 11, 12, 18; GREEN (pp. 98–99); YELLOW (p. 97), 11, 14, 18; SAXON BLUE (p. 105), 11, 12, 18; DARK BLUE (p. 121), 12, 16; WHITE (p. 123), 17

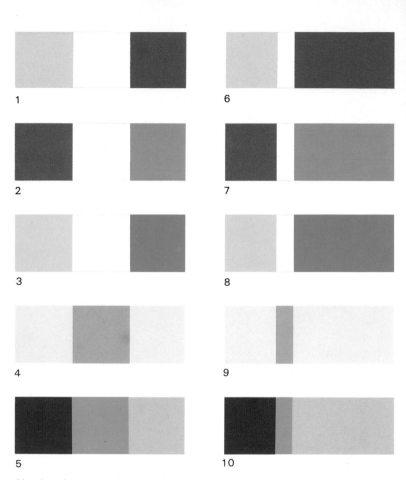

Varying the proportions can bring out more vivid and lively contrasts between colors to help achieve the effect you want.

Moving across from 1 to 6, for example, shows how reducing the amount of white and increasing the blue proportionally highlights the yellow-blue contrast for an attractive, summery outfit. A similar effect is achieved between 2 and 7, where peppermint green lends a gay mood to a patio luncheon table. A softer mood is expressed by a sherbet green accented with a light blue in 9.

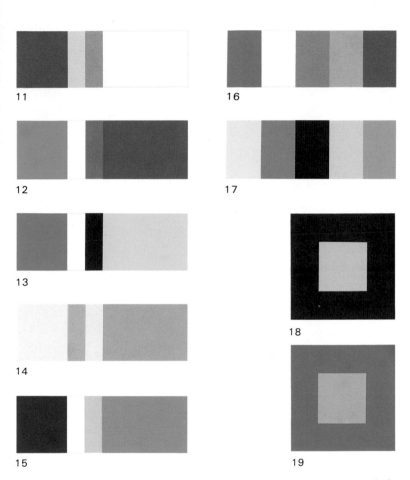

11

16

12

17

13

14

18

15

19

More complex color schemes with the addition of orange in 11 and 12 are full of summer cheer, while darker blues set the tone in 13 and 15.

Cool

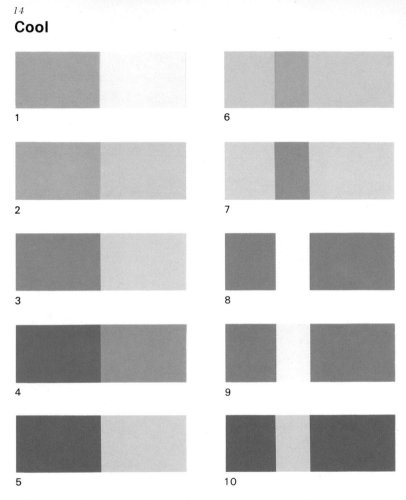

1
6
2
7
3
8
4
9
5
10

On the job, it is important to project an image of maturity and strength. Shades of blue and green, enhanced by gray tones, are a reliable way to communicate a smart and sophisticated attitude. For women, the shadings and combinations on these pages are especially effective, since they are authoritative but at the same time feminine.

Light shades of blue and green shown in 1, 2, 6, and 7 are subdued, while 5, 10, and 11 are comparatively bolder. A cheerful and refined sense is expressed in the grouping of greens, blues, and grays as in 9,

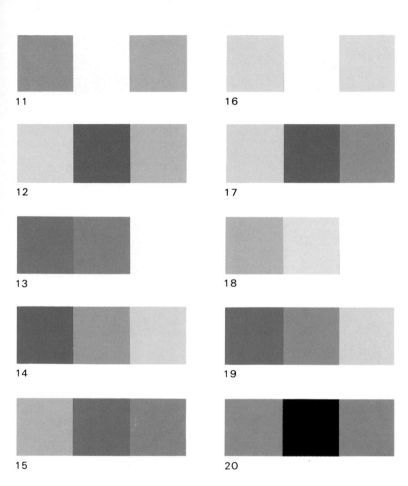

11

16

12

17

13

18

14

19

15

20

14, and 15. Light gray can tone down and at the same time highlight gradations in shades of the same colors, as in 14, 18, and 19.

For maximum effect, be sure to match the colors that express your position and personality.

See also GRAY (p. 124)

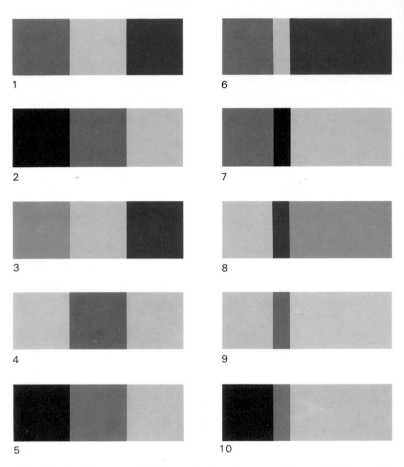

Alter the image you project by adjusting the proportions of lighter and darker colors and by adding a touch of bright color. For example the larger proportion of blue-gray in 7 is more cheerful than the equally proportioned colors in 2, but still suitable for an outfit for the office.

The balance of blue, gray, and dark green in 10 is more authoritative than in 5, but still has a feminine sensitivity. A bit of purple in 11 and 13 is more feminine still and would be appropriate for social gatherings.

The color combinations in 4, 9, and 14 are often used in Japan for

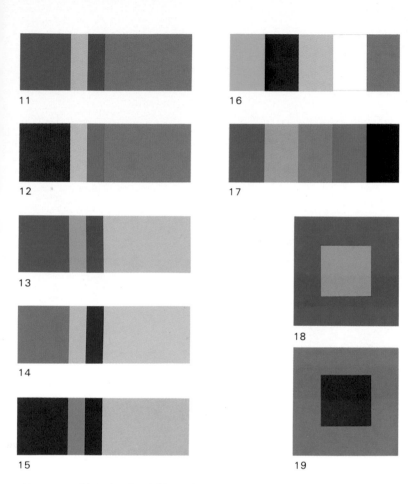

11

16

12

17

13

14

15

18

19

kimono and interior furnishings, but can be adopted for a new and exciting look for your own wardrobe.

Urbane

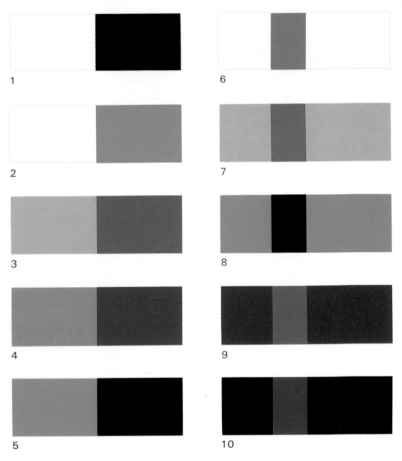

1

2

3

4

5

6

7

8

9

10

The high-tech look of the eighties is grounded in three colors—black, white, and gray. However, the addition of blue, purple, and green enhances the appeal of the high-tech image with sharper, more powerful contrasts. The overall effect is a clear, sharp image, just right for a business environment.

Gray, black, and blue in varying combinations such as in 3, 7, 12, 13, and 19 work especially well in offices, waiting rooms, or display areas. White, of course, gives these coordinations a clean and efficient appeal,

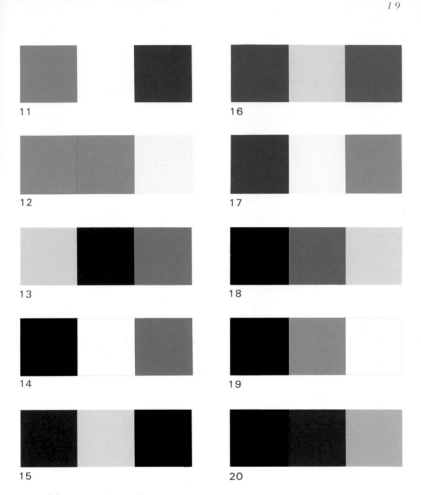

11
12
13
14
15
16
17
18
19
20

good for upmarket cafes, restaurants, or shops as seen in 1, 2, 6, 11, and 14.

Combinations with purple in them, such as as, 10, 11, and 15 are appropriate for a woman's wardrobe.

See also Black (pp. 126–127); White (p. 123), 12, 19

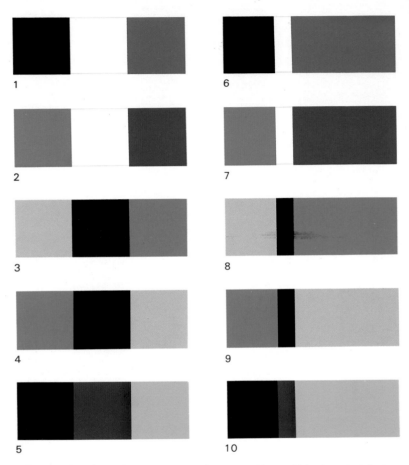

This section shows how to use varying proportions of black and white to alter and enhance the qualities of the basic high-tech look.

The clear and refreshing contrast between green and black and green and blue are accentuated by just a small section of white in 6 and 7, as compared to equal portions of each color in 1 and 2. Black plays a similar role with gray, green, and blue in 3, 4, and 9.

Using four colors, as in 11–15, results in a somewhat different look, but one that still retains the basic clear, sharp image that is the hallmark of high-tech.

11

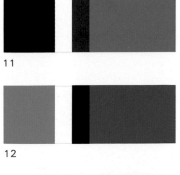

16

12

17

13

14

15

18

19

Resolute

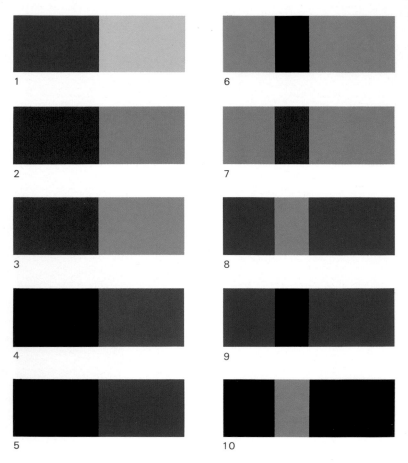

1

6

2

7

3

8

4

9

5

10

"Resolute" colors are cool and dignified. They help to present an image of maturity and propriety and also show an appreciation for subtle nuances. This is the kind of image you need to project during important meetings or in job interviews.

Combinations of gray and black in 4 and 7 project a serious, no-nonsense image, while a similar but somewhat lighter mood is achieved by combining gray and dark gray in 1, 5, and 8 and then with brown in 2 and 9.

Green brings out the coolness and confidence in gray, as seen in 11,

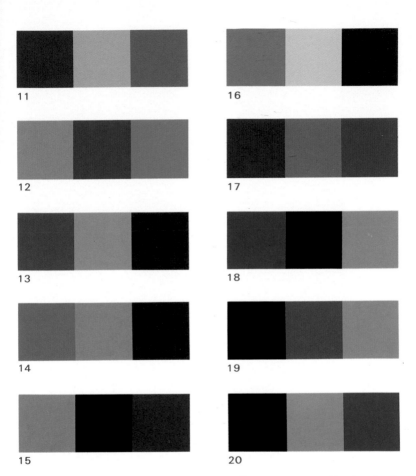

11

16

12

17

13

18

14

19

15

20

12, and 16, while 13 shows intelligence. If you want to add a touch of youth, a bright blue such as in 14 will do the trick. Fifteen is more traditional, while 18 and 19 suggest an appreciation of quality.

See also BLACK (p. 126), 6, 7, 8; DARK BLUE (p. 120), 1, 2, 3

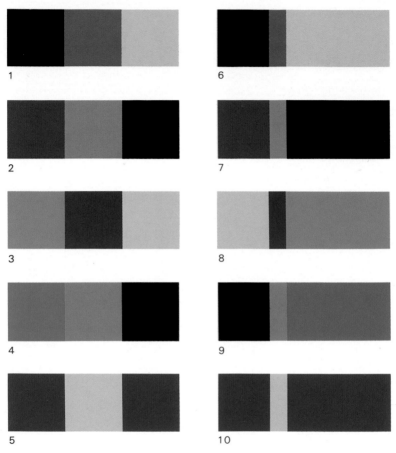

Gray and black are the base colors for this section, but with the addition of a third color, the overall effect is lighter and less somber. Even the basic black and gray combination changes with a larger proportion of light gray, as can be seen in the difference between 1 and 6.

The blue in 4 and 9 is an attractive color for men, while the wine-brown set off by a true gray in 5 and 10 is suitable for men and women.

Using too bright a color can throw the coordination off. A swatch of white as in 12 brightens the grays without overwhelming them. Similarly, the burnt orange in 13 is in harmony with the wine-brown and blue-gray.

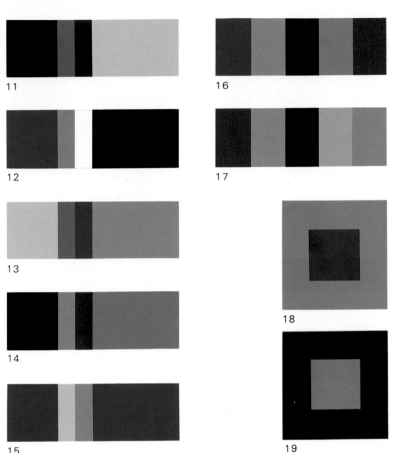

11
16
12
17
13
14
18
15
19

Any of the patterns in this section would be appropriate for men or women for business or social occasions.

Mature

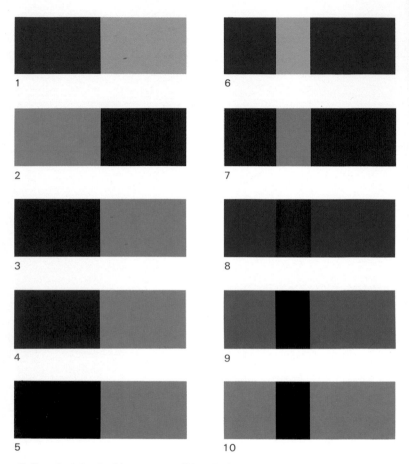

1

2

3

4

5

6

7

8

9

10

Fall and winter fashions are traditionally in darker colors and tones than spring or summer, but need not be dull or colorless. Shades of gray and brown as well as black are more attractive when paired with red, blue, green, or orange.

Green and gray are a cool combination in 11, while the wine, gray, and blue-gray combination in 12 is preppy. Sandy brown goes well with black, brown, or gray in coordinations 3, 5, 7, 10, 13, and 16. Gray and black are more outgoing with orange in 18.

These are attractive, mature colors for both men and women.

11

16

12

17

13

18

14

19

15

20

See also Brown (p. 115), 15, 16, 19, 20; Gray (p. 125), 20; Black (p. 126), 9

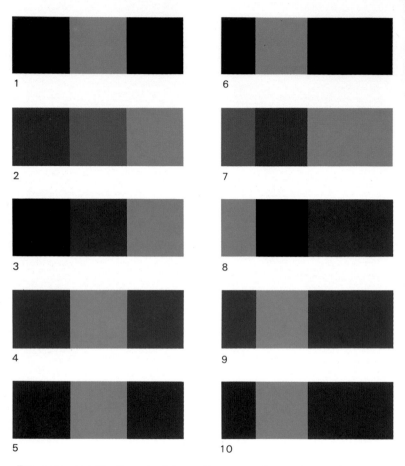

1

6

2

7

3

8

4

9

5

10

The color combinations in this section are rather sober and conservative. Choosing similar tones as in 2, 4, and 5 helps to suppress each color, causing them to look darker or duller.

However, reading across each line of color coordinations (1 to 11; 3 to 13), one can see how easy it is to accent each coordination with the addition of a band of bright color. The turquoise in 11, the orange-red in 13, and the orange in 14 all serve to lighten the tone in each coordination.

Be careful, however, not to choose colors that are too vivid, for they

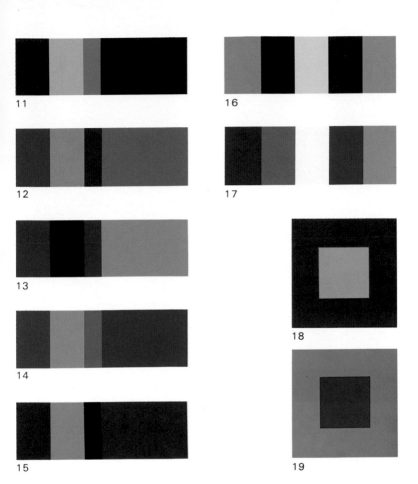

11

16

12

17

13

14

18

15

19

will overwhelm the more subdued colors and destroy the overall balance.

Earthy

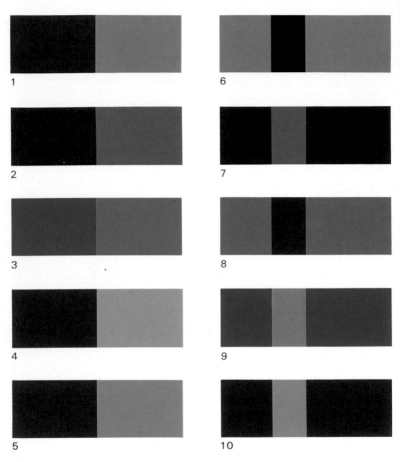

1

2

3

4

5

6

7

8

9

10

These colors are rich and warm. There is a hearty, old-fashioned feeling about these coordinations, which comes from the various shades of brown used. Colors such as these go best with things you plan to keep for a long time, such as furniture, coats, suits, shoes, and the like.

Colors such as wine in 2, 6, and 7 or olive in 3 and 9 blend very well in two-color coordinations with various shades of brown. When coordinating three colors or more, it is best to choose lighter shades to mix with darker ones—as in 11, 13, 14, 18, 19, and 20—to create a warm, cordial feeling.

11

16

12

17

13

18

14

19

15

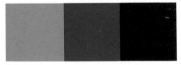

20

See also BROWN (p. 114), 4, 5, 10; BEIGE (p. 113), 15, 20; OLIVE (pp. 116–117), 3, 14

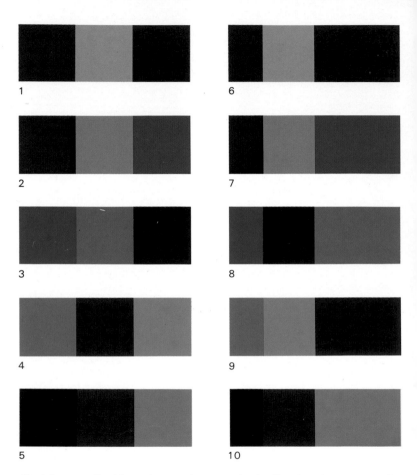

1

2

3

4

5

6

7

8

9

10

Dark brown offset by colors such as mustard, olive, burnt orange, and beige creates a warm and homey feeling. Coordinate sofa, chairs, table, carpet, and walls in a den or family room in combinations such as 1, 4, 6, or 8, choosing proportions to brighten up or tone down the mood, depending on your preference.

Living rooms or sitting rooms furnished with antiques need color coordinations such as in 3 or 8 to complement the overall effect.

Clothes for older men and women also include color combinations

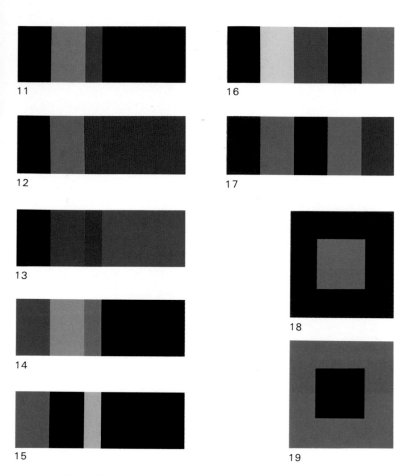

11
16
12
17
13
18
14
15
19

such as these, but can be given a more youthful appeal with a dose of burnt orange, wine, or sandy beige as in 12, 13, 14, and 15.

Arcadian

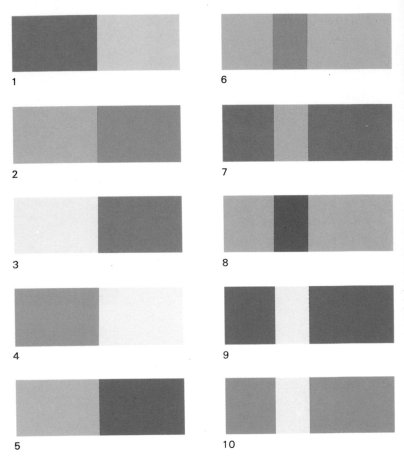

Arcadian colors are the hues of trees, grass, and water. Use these colors in your home to create a soothing environment. Furniture, drapes, and rugs covered in natural fiber fabrics such as cotton or linen and colored in coordinations such as these will give your home a clean and relaxing appeal.

Ivory, beige, and yellow-greenish colors are dominant in this group. There is a lot of warmth in 1 and 7, while 4, 5, 6, and 9 are naturally refreshing.

Adding lighter shades of green as in 12 and 16 gives a room a breezy

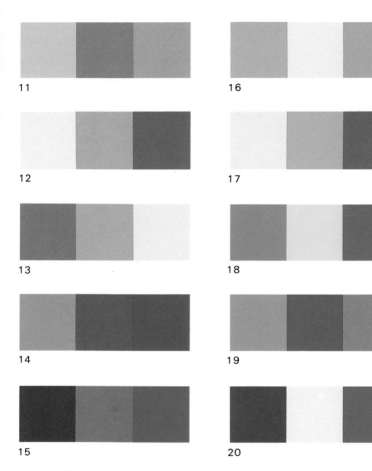

11

16

12

17

13

18

14

19

15

20

feeling. Darker shades of green as in 14 and 15 help to bring the outdoors inside.

See also BEIGE (p. 112); IVORY (p. 106); BROWN (p. 114); OLIVE (p. 116)

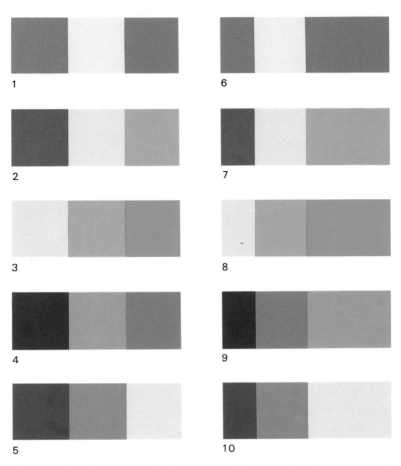

1

6

2

7

3

8

4

9

5

10

Ivory and beige are neutral colors and blend well with greens and browns to create a natural harmony. Ivory and beige allow other colors to stand out, but at the same time prevent them from being overwhelming.

For example, the green in 6 combines with the yellow ochre for a relaxed feeling. A light breeze is suggested by 3, while 8 reminds one of a cool meadow or pond in summer.

Add a dark or light color to these coordinations to accent the mood. A touch of dark green—in 11 and 15—accentuates the other greens and

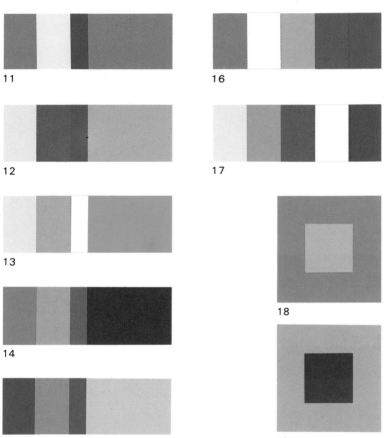

11

16

12

17

13

14

15

18

19

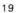

seems to emit the fragrance of a meadow in spring. Adding white to 13
suggests the wide outdoors of spring and summer.

Sensible

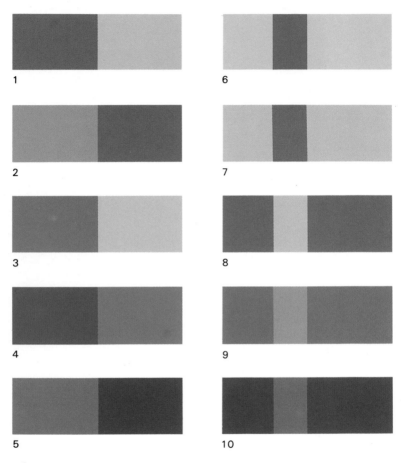

1

6

2

7

3

8

4

9

5

10

Gray is an important color in a wardrobe, not only for its versatility, but also for the different messages it can convey. Gray is a color with a gentle demeanor, perfect for autumn, winter, and spring. It is also a color for the business world, serious and respected. The key to these different moods is shade, tone, and coordination with other colors.

Gray with light gray or gray-blue as in 1, 2, 7, 9, and 12 are sensible coordinations for the office. Gray with brown is a sophisticated match in 2, 5, 8, 13, and 17 for a stylish outfit; 14, 15, 18, and 19 are adult without being stodgy.

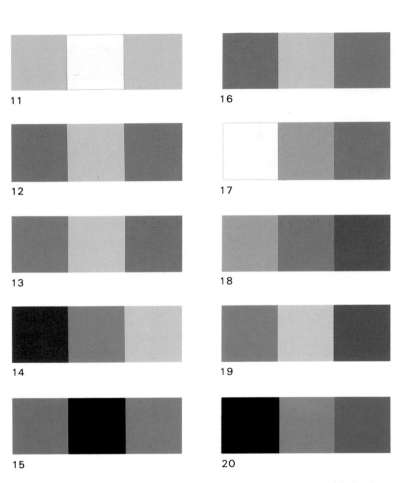

11

16

12

17

13

18

14

19

15

20

Remember that gray and other grayish colors can add sophistication to interiors and a refined sense to personal accessories.

See also Cool (pp. 14–17); Gray (p. 124)

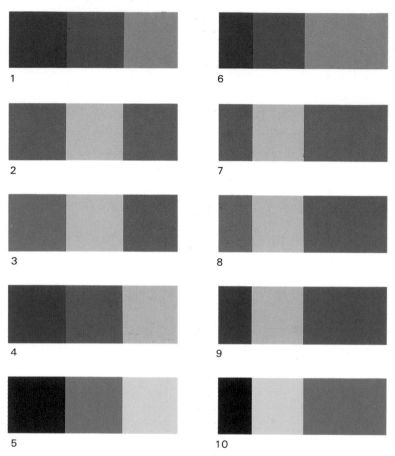

1

6

2

7

3

8

4

9

5

10

Highlight and enhance grays by combining them with colors that will complement but not compete. Use various shades of gray to enhance each coordination.

For example, in 1 and 6 a light gray combines well with dark gray and brown. The addition of a dark wine strip in 11 picks up the brown and dark gray without overwhelming the light gray. Similarly, in 12, a strip of green highlights the blue-gray section, making for an attractive early autumn coordination.

An otherwise pedestrian brown interior becomes special when supple-

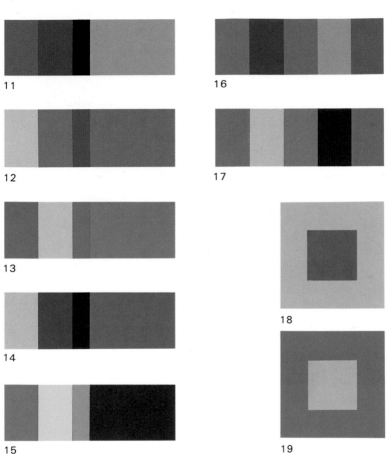

11

16

12

17

13

14

18

15

19

mented with dark gray and pinkish beige for an attractive yet composed
feeling, as in 4 and 9.

Tender

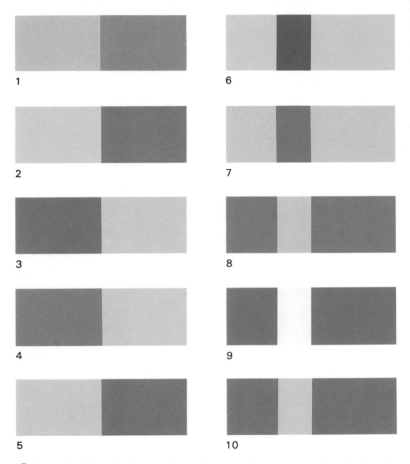

1

6

2

7

3

8

4

9

5

10

Pale and subdued colors such as the ones here are traditionally feminine colors. Their general tone is quiet and suggests early autumn or springtime fashions. Sweaters and other knitted garments are especially attractive in colors such as these.

The best balance for these combinations is achieved when you vary the degree of brightness using similar colors such as in 1, 4, 6, and 9. Subtle contrasts, such as in 1, 3, 7, and 10 have a sophisticated look.

Slightly stronger blues and grays mix well in three-color coordinations such as 14, 15, 16, and 19 and can be worn by men.

11

16

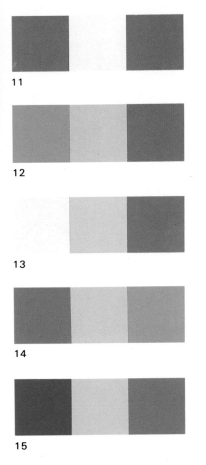

12

17

13

18

14

19

15

20

See also LAVENDER (p. 110), 4, 5, 10; SAXON BLUE (p. 104), 7; GRAY (p. 124), 10

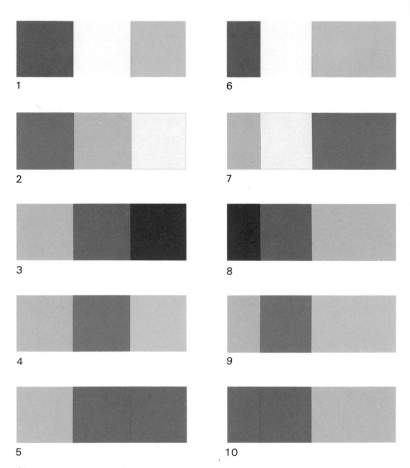

You almost cannot miss when you coordinate with blues, grays, and purples. There is a natural harmony between these colors, and they create a look that is soft, cool, and elegant.

Pale blue blends well with purple in 1 and 6 and gray in 4 and 9, for a look that is soft and feminine. The color ratios in 7 make it sharper and more masculine than the same colors in 2, while purple, gray and lavender are a rich combination in 3 and 8.

The addition of a fourth color highlights and brings richer hues into focus, as with the purple in 13 and 15 and the blues in 14. A very pale

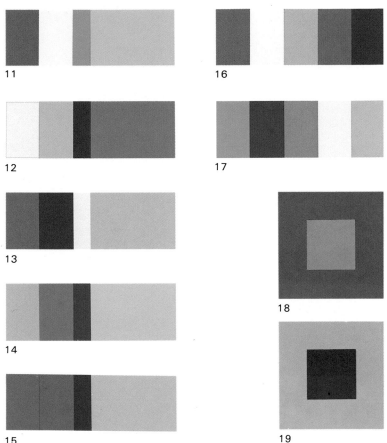

11

16

12

17

13

14

18

15

19

gray-blue in 12 and 13 also helps to accent the purples and blues around it for a delicate coordination.

Alluring

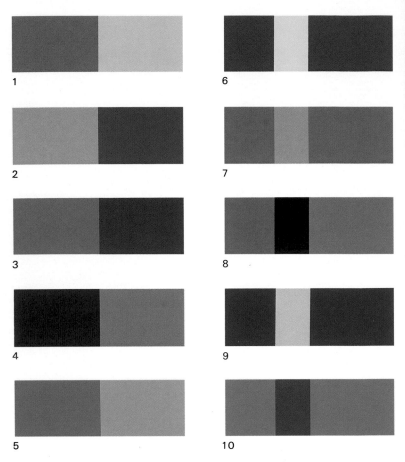

Feminine colors are not only limited to the pale color coordinations in the previous section. Deep, rich hues such as the ones in this section are also feminine. These particular shades of purple, purple-red, and pink have traditionally been classified as colors for women. However, attitudes about color have undergone changes in recent years, and certain coordinations can now be seen in men's fashions.

Particularly feminine combinations include lighter shades of pink as well as lavender and purple as in 1, 2, 3, 7, 8, and 16. Crossover coordinations include gray and darker blues, as in 4, 15, 17, and 20.

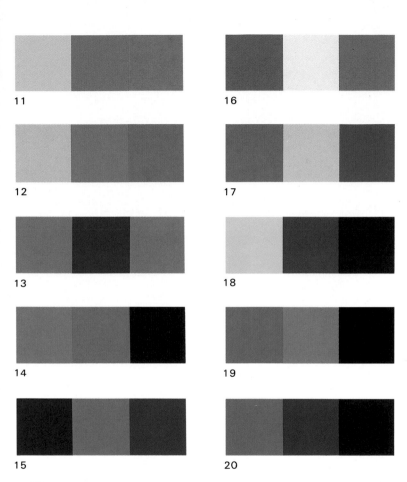

11 16

12 17

13 18

14 19

15 20

For women, these colors go with most anything from clothing to interior designs and accessories. For men, the possibilities are limited to clothing such as shirts, ties, and sweaters.

See also GRAY (p. 124), 2, 3, 8, 9

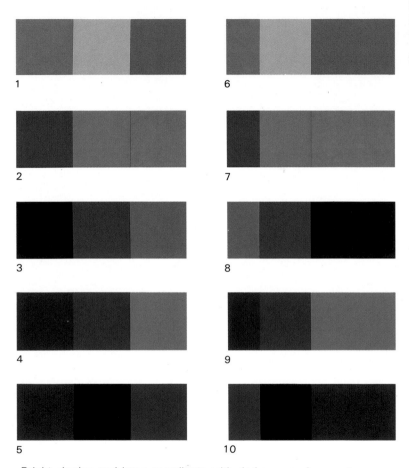

1

6

2

7

3

8

4

9

5

10

Bright shades and hues coordinate with darker ones for greater contrast. The overall effect is more appropriate for interior color schemes with a decidedly feminine touch.

Equal portions of salmon pink, gray, and light grayish pink in 1 create a light and breezy feeling, while the larger portion of gray in 6 makes for a much more subdued effect. In 7 the salmon pink is very strong and combines with the blues for a soft and fragrant atmosphere perfect for a commercial establishment such as a restaurant. The pink beige in 12 tones the effect down.

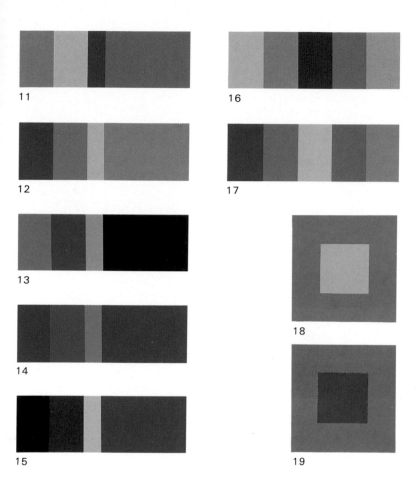

11

16

12

17

13

14

18

15

19

The colors in 4 and 9 reflect a Japanese sensibility that can work well even in a Western home interior. The addition of blue in 14 helps to lighten the effect for a fashionable autumn or early spring outfit.

Dreamy

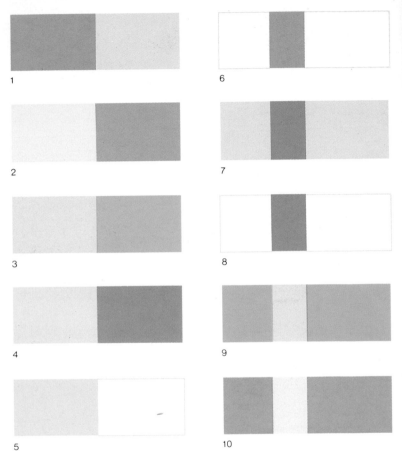

1

6

2

7

3

8

4

9

5

10

Soft pastel colors such as these have a transparent, cool quality even though they are from a warm color family. Pastel coordinations such as these seem ideal for young women and little girls in summer.

Primarily the mood of these coordinations is set by pink in 1, 6, and 10, lavender-gray in 4, 7, 8, and peppermint green in 5 and 9. Note how the colors seem to change, depending on their shades and proportions.

Three color combinations are best when you choose pastels for your home. Make your bedroom, bathroom, and breakfast nook cheerful and

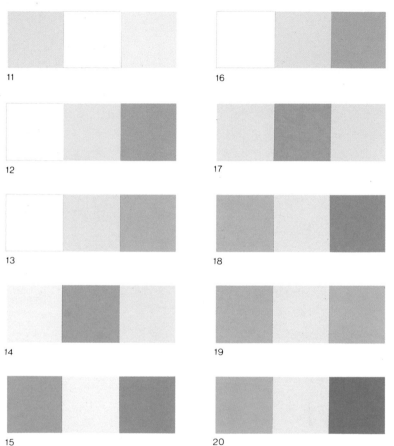

11 16

12 17

13 18

14 19

15 20

inviting by decorating them in color coordinations such as 15, 17, 18, and 20.

See also WHITE (p. 122), 2, 7, 9; LAVENDER (p. 110), 6

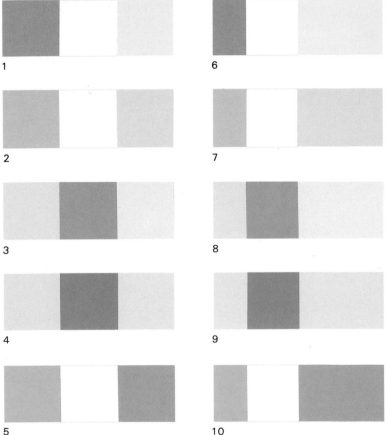

1

6

2

7

3

8

4

9

5

10

The addition of white to pastel coordinations brightens them up by creating a cleaner, sharper image. Colors remain soft and warm but with a more lively and refreshing appeal.

In 1 and 6, for example, the section of white sharpens the contrast between the pink and saxon blue, thereby causing the pink to stand out more. Similarly in 5 and 10, white sets off the orange-beige and gives the pink a sweet taste.

The same sort of effect can also be achieved in more complex coordinations by pairing lighter and slightly darker shades of the same color.

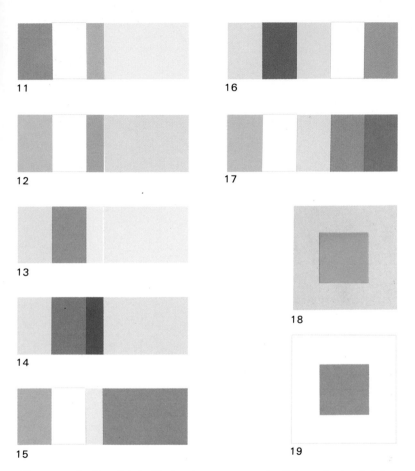

11
16
12
17
13
14
18
15
19

For example, the pink in 13 stands out next to the lighter shade of pink, while purple dominates the lavender next to it in 14.

Sweet

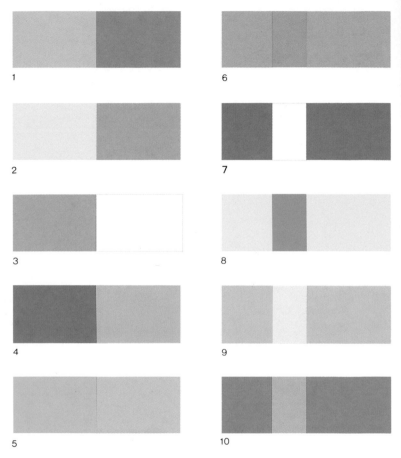

1

2

3

4

5

6

7

8

9

10

Springtime is for healthy, outdoor colors such as these. Pale orange, pink, cream, and apricot are youthful colors, fun to use in clothing, patio and backyard furniture, sports gear, and even cosmetics. The colors here have a soft and powdery quality, but are also bright and cheerful.

Different shades of like colors such as in 1 and 9 go well together, or try sharp contrasts such as in 4, 5, 6, and 8 for a more colorful effect.

With three-color coordinations, bright contrasts can be had, as in 11, 14, 15, 19, and 20. Or try rearranging the order of the combinations for a

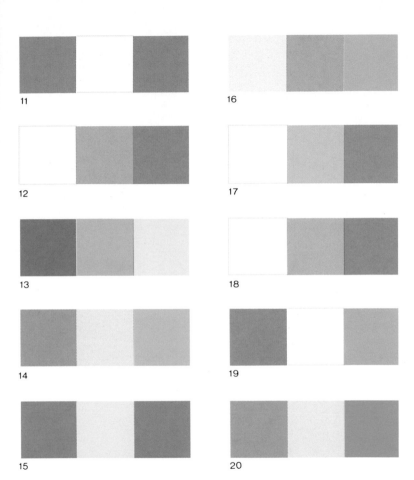

11

16

12

17

13

18

14

19

15

20

different effect, as in 13, 16, and 20. White also plays an important role here in defining the colors, as can be seen in 11, 12, 17, 18 and 19.

See also PINK (pp. 108–109), 1, 2, 6, 7, 8; TURQUOISE (p. 103), 13, 14, 17

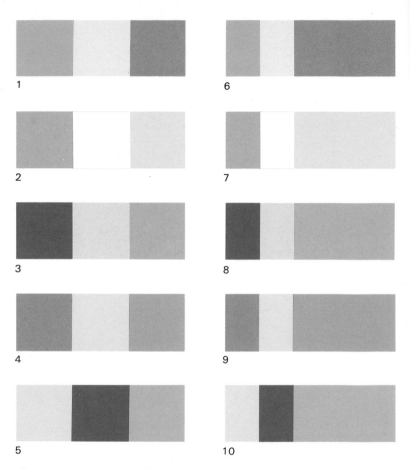

1

6

2

7

3

8

4

9

5

10

Bright pastels are versatile colors that can be applied to almost anything from home interior decorating to fashion, sporting gear, personal accessories, and stationery goods. Mix and match colors such as pink, yellow, apricot, and turquoise for a sweet and summery feeling.

Numbers 1 and 6 combine pink, cream, and green for a merry coordination for the bedroom, while 11 adds a bit of yellow for accent. A sunny yellow in 2 and 7 combines with white and apricot for a versatile coordination to use with anything from skirts and blouses to sofas, umbrellas, and dishware.

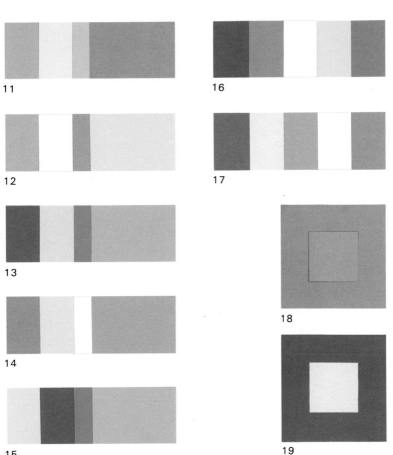

11

16

12

17

13

14

18

15

19

Red, orange, and beige in 3 and 8 lend warmth to a room, while green, yellow, and pinkish red combine for a fresh and natural feeling in 5, 10, and 15.

Breezy

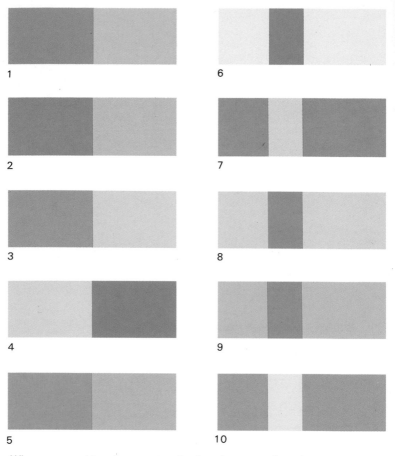

When you want to relax, you need colors that are soft and natural like the combinations of brown and tan shadings here. Notice how the greens in 1, 2, and 9 accent a natural feeling, while the oranges in 1, 2, 5, 7, and 9 are warm and soothing. Ivory in 3, 4, 6, and 8 is restful and mild.

Other rooms of the house such as the kitchen, bathroom, or family room are attractive and inviting when decorated in brighter colors. The combinations in 14 and 20 pick up the mood in a kitchen while still allowing you to relax. The blue-gray shades in 12, 13, 15, 16, and 18 make for

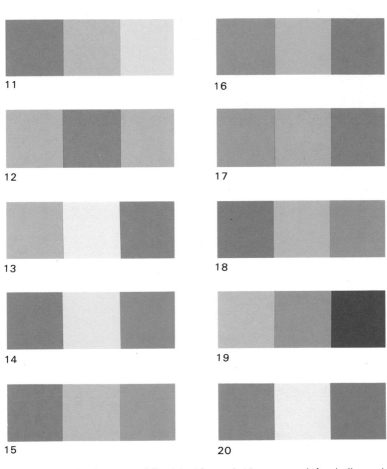

11

16

12

17

13

18

14

19

15

20

a pleasant bathroom, while 11, 12, and 13 are good for halls and entryways.

Top things off by coordinating a sensible weekend wardrobe using the color combinations in 13, 15, 18, or 19.

See also Beige (p. 112); Ivory (p. 106), 1, 2; Brown (p. 114), 6

Use more yellow to give a sunny and cheerful complexion to the casual coordinations here. For example, the brown and pale green in 1 and 6 are enlivened with a band of yellow for a naturally refreshing feeling.

Yellow paired with orange and blue in 5 and 10 results in a bright and youthful coordination perfect for swimsuits, towels, umbrellas, and other items for the beach in summer. For a relaxing mood use a cream as in 2, 4, 7, and 9, to decorate the living room, den, or bedroom.

Four-color coordinations can be accented with single bands of bright colors as in 11, 12, 14, and 15. The five-color combinations in 16 and 17

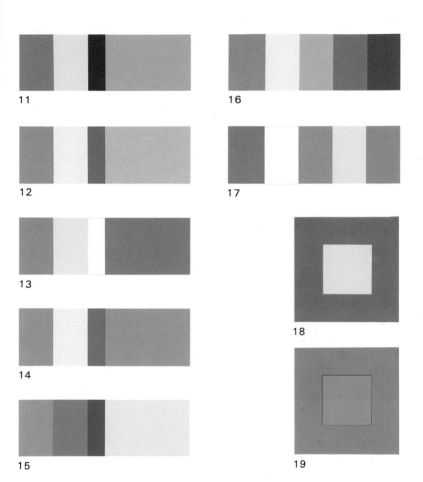

can be used to help coordinate more complex schemes for interior decorating.

Energetic

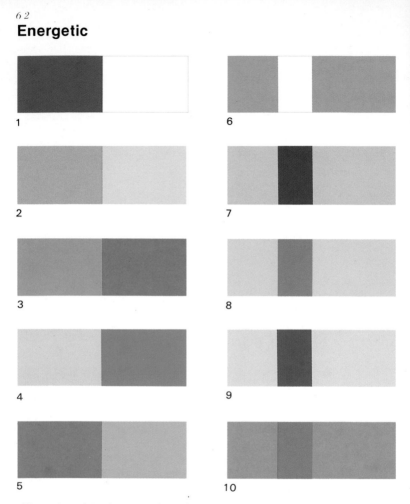

There is a lot of energy in colors such as the ones here, and they transmit that energy to whatever they are applied to. Basic colors such as red, yellow, blue, green, and orange in vivid tones are summer colors for sports, travel, parties, and everyday wear.

White brings out the brightness in colors in 1, 6, and 16. Or contrasting colors can be combined just for the fun of it, as in 2, 3, 4, 7, 8, and 10.

Things made from plastic such as dishes, cups, pens, radios, cassette players, telephones, chairs, tables, etc. are attractive in bright colors

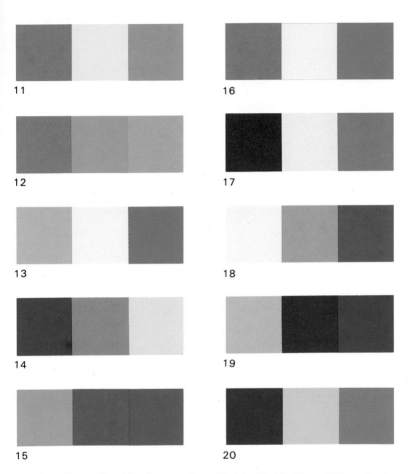

11

16

12

17

13

18

14

19

15

20

such as these. Combinations such as 11, 14, 15, 16, 19, and 20 are fresh and lively colors for plastic goods.

See also YELLOW (p. 97), 13, 20; GREEN (p. 99), 19; OLIVE (p. 117), 16; DARK BLUE (p. 121), 16, 17, 18

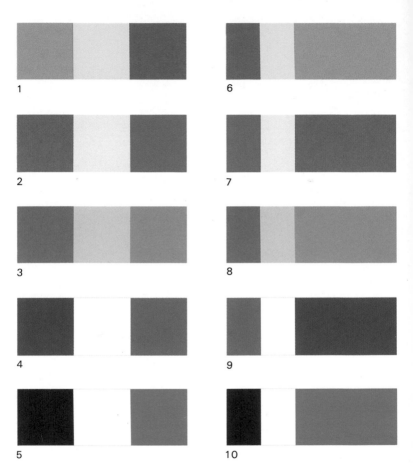

1

6

2

7

3

8

4

9

5

10

Use both hot and cool colors for bright natural coordinations in fashion and interior decorating. Orange, yellow, and green express a healthy, natural, outdoor feeling in 1, 3, 7, and 8. The combinations of blue, white, and orange in 4 and 9 evoke images of summertime fun at the beach.

Five and 10 are quintessentially Italian, with an up-to-date, clean, and modern appeal for the kitchen or a commercial establishment such as a restaurant, cafe, or ice cream parlor.

Adding a fourth color sharpens contrasts and brings out clean, clear colors, as with a dark blue in 12 and white in 13, 14, and 15. Note how us-

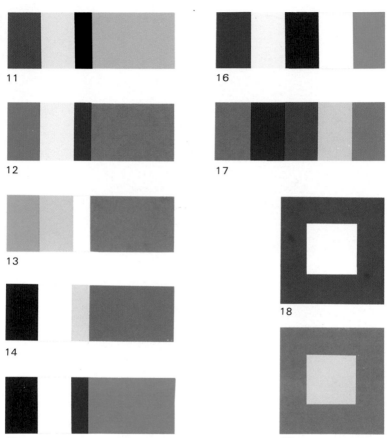

11

16

12

17

13

14

15

18

19

ing a fourth color can change the overall contrast between the colors in
the coordination.

Luxurious

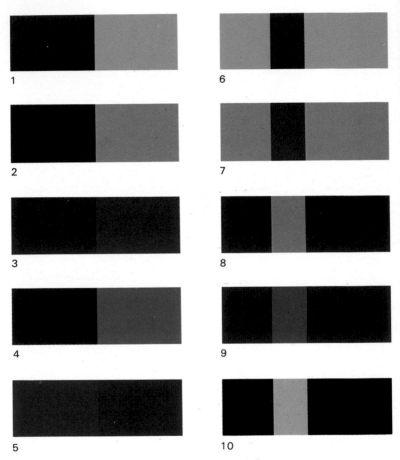

1

2

3

4

5

6

7

8

9

10

These colors express an older, more traditional sense of wealth and luxury. Rich velvety reds, radiant gold, lush purples, and black are the basic colors of this group. They can be seen in tapestries, in antique furniture, or in drapes, bedspreads, and carpets. Although not widely used in today's fashions, colors such as these were the mainstay of European and even North American clothing for several centuries.

Purple and gold blend for a rich contrast in 2 and 7, while black brings out deep hues in 10 and 20. A modern update is achieved in 12, 13, 14, 17, and 18 by blending lighter tones for a nouvelle flair.

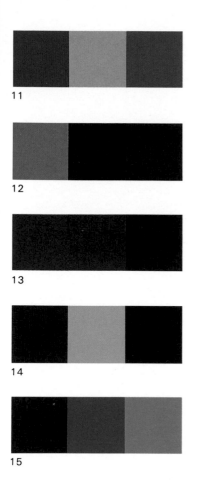

11

12

13

14

15

16

17

18

19

20

See also Wine (pp. 118–119); Gray (p. 125), 13; Black (p. 127), 14

Deep, rich colors are especially attractive when used in contrasting combinations such as the ones here. Combining colors that are too similar is not recommended, since they tend to blend into each other.

Coordinations of a deep wine red with gold and violet are a classic combination, while purple, lavender, and plum in 4 and 9 are more up-to-date. Chartreuse, orange, and a dark green in 2 and 7 have lots of holiday cheer and can be used to decorate rooms and banquet tables or in coordinating wear for winter holidays.

In three-color combinations, black is especially effective in

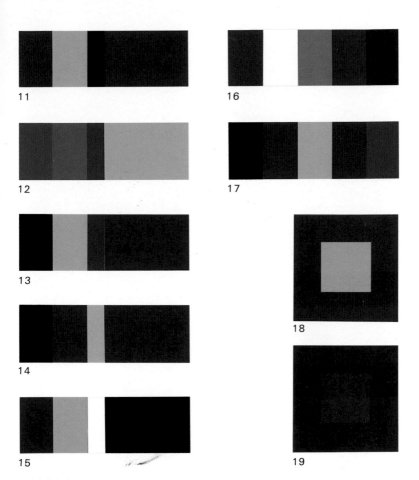

highlighting the richness in the other colors and of the coordination as a whole, as in 11, 13, 14, and 15.

Folksy

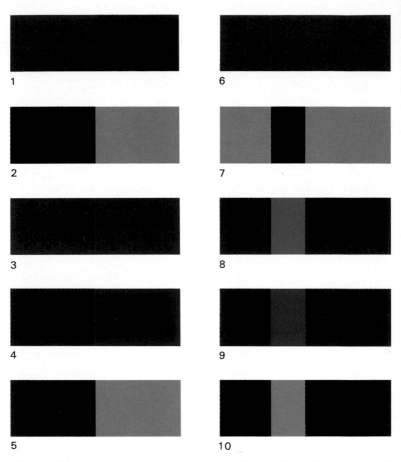

Deep, rich colors such as these are earthy in tone but with a degree of brightness that goes well in autumn fashions and interior decorating. The use of dark brown, olive green, and brownish red lends a folk art flavor to these coordinations.

A rich golden yellow paired with olive brown in 5 and 7 is a perfect combination for the harvest season in September and October. Dark green and red in 1 and 4 bring to mind thoughts of Thanksgiving and Christmas.

Three-color coordinations have a stronger folksy flavor, as in 11, 13,

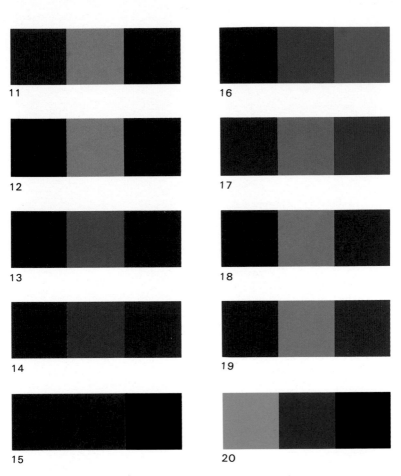

11

12

13

14

15

16

17

18

19

20

and 19. Use coordinations such as these to bring a warm, country feeling to your home.

See also RED (p. 93), 14; ORANGE (pp. 94–95), 3, 4, 5, 15, 19; BROWN (p. 114), 4, 5, 9; WINE (p. 119), 16, 19

72

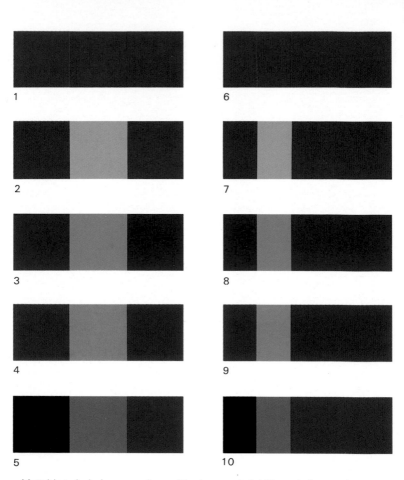

1

6

2

7

3

8

4

9

5

10

Matching dark, heavy colors with clear and vivid hues brings out a warm and human contrast within each coordination. Use these combinations in your home to create a relaxing, cordial environment for family and friends. Apply these coordinations to almost everything, from furniture to paint, carpets, tablecloths, napkins; dishware, towels, bedspreads, to create an atmosphere that is warm and inviting.

A rustic feeling for the kitchen or dining room can be centered around the color coordination in 1 and 6, with a lighter mood coming with the addition of ivory in 11. The contrast between dark green, olive, and red in 1

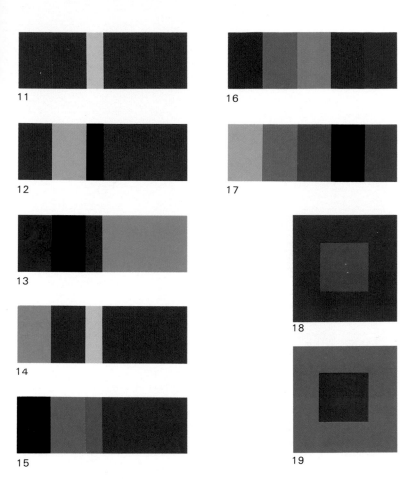

and 7 make for a charming bedroom. Purple, green, and red are an eccentric combination in 3 and 8, while a stripe of orange highlights the warm and earthy browns in 15.

Dynamic

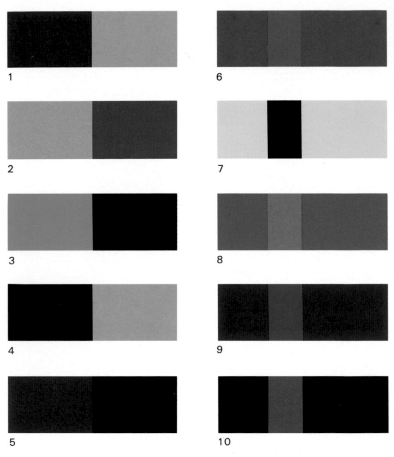

1

6

2

7

3

8

4

9

5

10

Brilliant, energetic colors such as these suggest vitality, health, aggressiveness, humor, and youth. The coordinations here are made up of strong primary colors that broadcast loud and clear to everyone around. Use these colors in big, dramatic ways to make a splash wherever you go.

These are two ways to coordinate bright colors such as these. The first is to use two primary colors as in 1, 2, 6, 8, and 9 to create a fun, lighthearted contrast. The other is to create a powerful and vivid contrast using a primary color and black as in 3, 4, 5, 7, and 10.

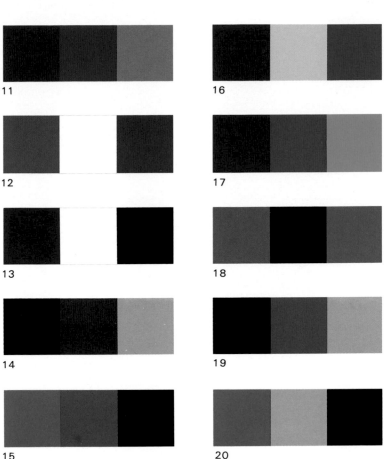

11

12

13

14

15

16

17

18

19

20

Three-color combinations are not quite so powerful, but they are certainly lively and attractive. White brings a clear, refreshing contrast to a coordination, as in 12 and 13.

See also RED (p. 93), 12, 15, 20; YELLOW (p. 97), 12; DARK BLUE (p. 121), 12; BLACK (p. 127), 18

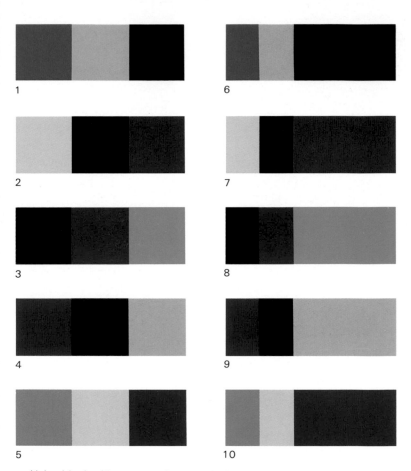

Using black with strong colors results in a dramatic effect. Bright colors such as the ones here are widely used for sports equipment and wear at the beach, in the mountains, and on the ski slopes.

Blue, red, and yellow appear many times brighter when paired with black as in 1, 3, 4, 6, 7, and 9. Less dramatic but just as appealing, 5 and 10 combine three primary colors for a cheerful effect, useful in decorating a children's playroom or designing children's toys.

Four-color coordinations are more challenging, since they provide a

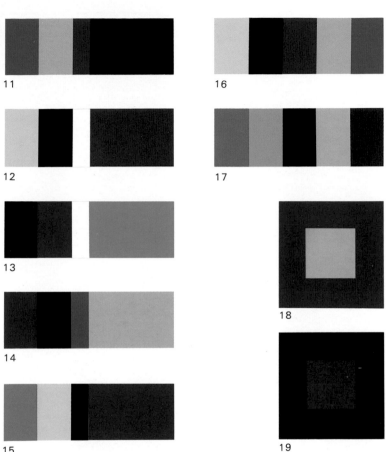

11

12

13

14

15

16

17

18

19

chance to alter the overall impact of each coordination by changing the proportions of each color.

Basic Information

The Color Image Scale

The eighteen color images presented in detail in the first section (pp. 6–77) are shown here in abbreviated graphic form. One to three representative coordinations from each section are included, with the upper one lighter and softer in tone than the one below.

Colors are ranked horizontally from warm to cool and vertically from soft to hard. A scale of from 0 to 3 is used for each value, read from the center outward.

Use this scale to compare and contrast the different color images. Then choose which one projects the image that is right for your needs and turn to the appropriate section for a more varied and detailed presentation of each image.

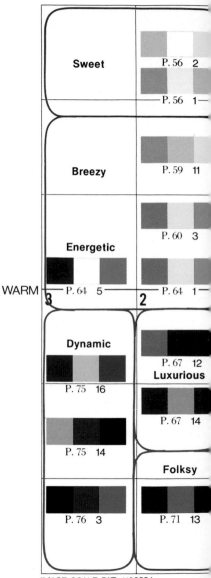

IMAGE SCALE PAT. 1106334

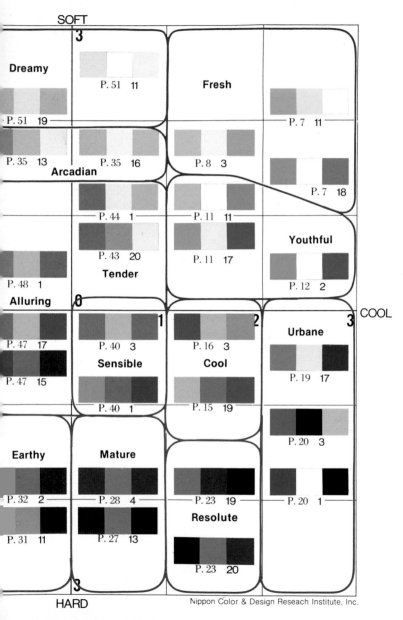

SOFT

Dreamy
P. 51 11
P. 51 19

Fresh
P. 7 11

P. 35 13 P. 35 16
Arcadian
P. 8 3
P. 7 18

P. 44 1
P. 43 20
Tender
P. 11 11
P. 11 17
Youthful
P. 12 2

P. 48 1
Alluring

COOL

P. 47 17
P. 40 3
P. 16 3
Urbane
P. 19 17

P. 47 15
Sensible
Cool
P. 40 1
P. 15 19

P. 20 3

Earthy
Mature
P. 32 2
P. 28 4
P. 23 19
P. 20 1

P. 31 11
P. 27 13
Resolute
P. 23 20

HARD

Chromatic Colors

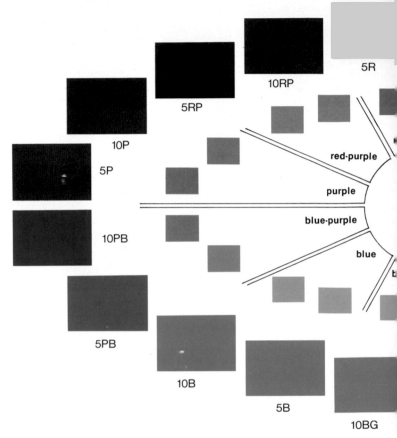

In the world of colors there are chromatic colors such as red, orange, and yellow; white, black, and gray are achromatic. Chromatic colors can be organized into a circular chart such as the one here showing the transitions of the color spectrum.

Most color scales are based on 10 hues. However, this chart breaks down each transition into two values to show more subtle gradations between colors. In addition, the outer circle shows vivid colors, to contrast with bright clear shades of the same color in the inner circle.

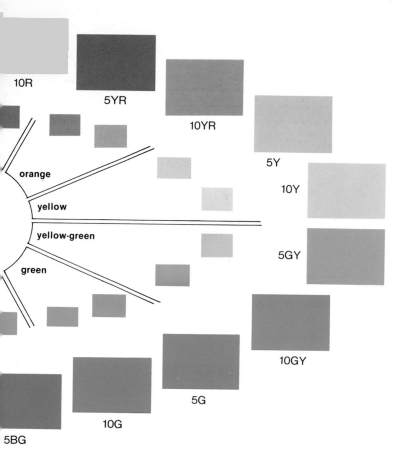

10R

5YR

10YR

5Y

orange

yellow

10Y

yellow-green

5GY

green

10GY

5G

10G

5BG

Opinions may differ regarding the particular warmth or coolness of a color, but 10R and 5B are generally accepted by most people as the warmest and coolest colors, respectively, in the circle of hues. Use the color circle here to help identify and distinguish the relationships in the color spectrum. (Pages 82–83 provide a much more detailed color chart.)

Hue and Tone System

A Book of Colors uses 180 different chromatic colors and 10 achromatic ones. The color graph on this page illustrates 180 variations with grada-

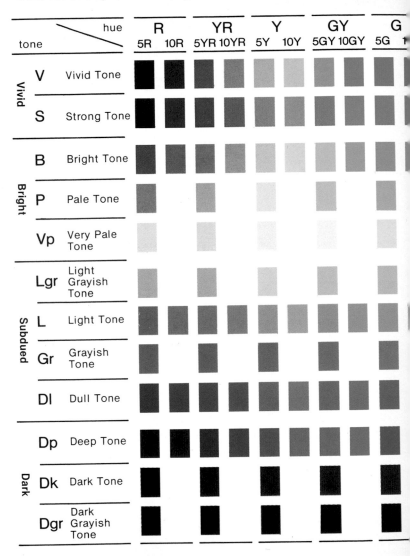

tone		hue	R 5R	10R	YR 5YR	10YR	Y 5Y	10Y	GY 5GY	10GY	G 5G
Vivid	V	Vivid Tone									
Vivid	S	Strong Tone									
Bright	B	Bright Tone									
Bright	P	Pale Tone									
Bright	Vp	Very Pale Tone									
Subdued	Lgr	Light Grayish Tone									
Subdued	L	Light Tone									
Subdued	Gr	Grayish Tone									
Subdued	Dl	Dull Tone									
Dark	Dp	Deep Tone									
Dark	Dk	Dark Tone									
Dark	Dgr	Dark Grayish Tone									

tion of color tone vertically, from vivid through bright, dull, and dark, and hue horizontally, from 5R through 10RP. Note how greatly a color changes as the tonal value increases and decreases and also the similarity between different hues with the same tonal value.

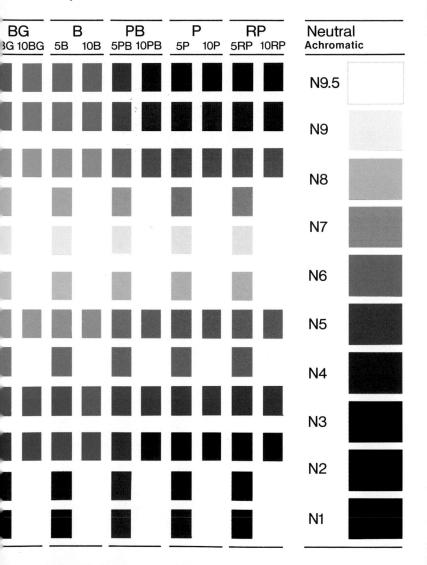

Hue and Tone

Paints are made by blending three chromatic colors—red, yellow, and blue—in varying proportions and combinations to achieve the desired color. For example, by mixing red and yellow together, the color (hue) orange is created. Adding an achromatic color (white, gray, or black) determines the tone of the color.

Chromatic Colors

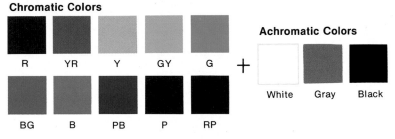

Achromatic Colors

Mixing black or white with a vivid chromatic color results in a bright, clear tone. For example, mixing red with white results in a bright, clear, and refreshing tone of pink, while red and black produce a dark but clear hue. (For more detailed gradations, see page 82.)

Clear Colors

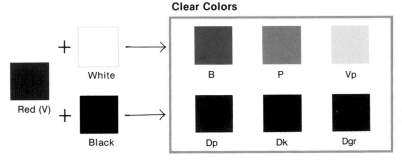

Dull or subdued tones are achieved by mixing various shades of achromatic gray with chromatic colors. As the illustration below shows, tones ranging from strong through light grayish are possible when gray is used to determine the tone of a color.

Grayish Colors

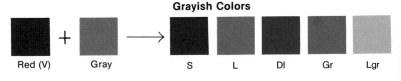

Tone Graph (5R)

Tones here are only representative. There are numerous in-between tones not listed.

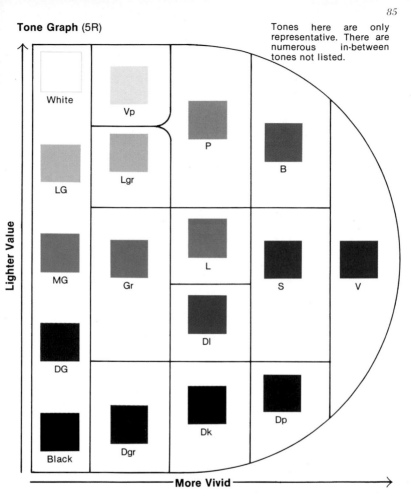

Lighter Value

More Vivid →

Every hue can be catagorized between extremes of light and dark, clear and cloudy, bright and dull. These catagories represent the tone of a particular color. The above graph illustrates the relationship among the tones.

There are twelve general categories of tone illustrated here. These were made by combining the five achromatic colors (white, light gray, medium gray, dark gray, black) and red (5R). The colors in the outer layer are clear and bright, while the ones in the inner layer are grayish and dull.

Tone and Image

Vivid Tones:

V vivid, brilliant, powerful, clear, and full of life.

S slightly dull compared to "V" tones but are still strong and substantial.

Bright Tones:

B bright and clear, like precious stones.

P sweet, dreamy, pale.

Vp delicate and whitish, soft.

Dull or Subdued Tones:

Lgr quiet and reserved.
L warm and peaceful.
Gr neutral and dry.
Dl subdued.

Dark Tones:

Dp deep and thick, with a practical edge.

Dk subtle, with an image of high quality.

Dgr almost black, with a hard and heavy feeling.

Achromatic colors are generally considered to have a cool image. White is refreshing, while black is dark and heavy. Gray ranges from light to dark shades but most often is considered to be a calm and quiet color. Because achromatic colors have no hue, they are best used to complement chromatic coordinations.

Complementary and Contrasting Colors

When trying to decide which color coordination you want to choose, you have to consider its purpose and also the image that coordination projects. Coordinations can be broken down into two general catagories: complementary or contrasting.

Complementary coordinations use like colors (example 1) or like tone values (example 3).

Contrasting coordinations are most effective when you pair opposite colors (example 2) or colors whose tones are very dissimilar (example 4).

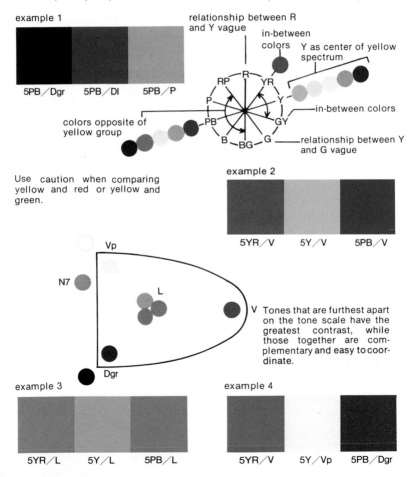

example 1

5PB/Dgr 5PB/Dl 5PB/P

relationship between R and Y vague

in-between colors

Y as center of yellow spectrum

in-between colors

colors opposite of yellow group

relationship between Y and G vague

Use caution when comparing yellow and red or yellow and green.

example 2

5YR/V 5Y/V 5PB/V

V Tones that are furthest apart on the tone scale have the greatest contrast, while those together are complementary and easy to coordinate.

example 3

5YR/L 5Y/L 5PB/L

example 4

5YR/V 5Y/Vp 5PB/Dgr

Tone and Image

When coordinating colors on your own, first think about the image you want to project. Keeping the image you want in mind, see how to vary it by changing the color tones.

example

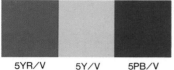

5YR/V 5Y/V 5PB/V

The color coordination above contrasts vivid tones for a vibrant and healthy look. See how changing the tone changes the mood of this coordination in the four combinations below.

In the column on the left, each coordination has the same tonal value. Below, the three color tones vary in each coordination.

5YR/B 5Y/B 5PB/B
Bright tones are soft and fun (see p. 62).

5YR/V 5Y/Vp 5PB/V
A very pale tone in the middle gives a sporty, casual image.

5YR/Lgr 5Y/Lgr 5PB/Lgr
Light grayish tones are quiet and peaceful.

5YR/Gr 5Y/Lgr 5PB/Gr
A chic and sophisticated look (see p. 39).

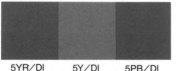

5YR/Dl 5Y/Dl 5PB/Dl
Complementary tones are calm and composed.

5YR/Dl 5Y/Lgr 5PB/Dl
Soft and snappy.

5YR/Dk 5Y/Dk 5PB/Dk
Dark tones are heavy but graceful.

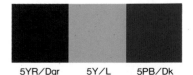

5YR/Dgr 5Y/L 5PB/Dk
A light tone in the middle projects a neat and refreshing image.

As the examples on the previous page show, using three colors results in lively and sometimes brilliant contrasts. This shows how to use different tones of the same color for equally varied and colorful contrasts.

Here different tones of yellow are combined to bring out their warmth.

5Y/Dgr　　5Y/Vp　　5Y/B

Contrast dark and light tones for a striking effect.

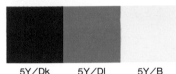

5Y/Dk　　5Y/Dl　　5Y/B

A slightly more subdued tone.

Yellow and yellow-red coordinate well for a look that is light and cheerful. White adds a fresh and bracing feeling.

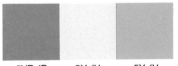

5YR/B　　5Y/Vp　　5Y/V

Use a very pale tone for a soft look.

5YR/B　　White　　5Y/B

White adds a sweet appeal (see p. 56).

Combining different tones of pale blue results in a cool, sharp, and sporty contrast.

5PB/Dgr　　5PB/Vp　　5PB/V

A cool and sporty contrast.

5PB/Dgr　　5PB/Dl　　5PB/P

A cool and quiet coordination (see p. 19).

Try coordinating opposite colors such as purple-blue and yellow-red or yellow for a warm and playful combination.

5PB/V　　5PB/Vp　　5YR/V

Orange brings out a healthy glow.

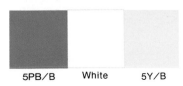

5PB/B　　White　　5Y/B

Soft and youthful (see p. 12).

Separation and Gradation

Contrasting equal proportions of two colors results in an unattractive combination where the colors compete with each other. A neutral color such as white separates such colors for a look that is clean and sharp.

5R/V 5BG/V

Opposite colors compete with each other.

10B/V White (N 9.5)

Vivid blue and white in a 1:1 ratio for a cool feeling.

Separate them for a clean and sharp look.

In an 8:2 ratio, white provides the accent.

A cool mood complemented by a warm red.

A swatch of yellow provides a youthful accent.

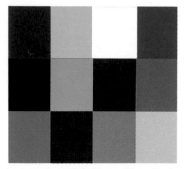

An overall cool feeling with a flashy red accent.

White accented with blue and yellow is refreshing.

Use black for a modern, progressive impression.

Form a gradation scale by lining up five or more hues and tones, and use the scale to better understand the subtle differences between them. The lower half of the page shows how to use a graded scale combining hue and tone. Add accents for a better overall color balance.

Compare and note the subtle differences between these monochrome tones. The bottom scale shows how color can also be used in this sort of scale.

To use the graded scale in deciding a coordination, first choose the base color. Here, yellow is used for a warm and mellow feeling.

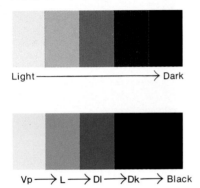

Light ⟶ Dark

G ⟶ B ⟶ PB ⟶ P ⟶ RP

Vp ⟶ L ⟶ Dl ⟶ Dk ⟶ Black

Light ⟶ Dark

Here various colors of different hues have been arranged on a graded scale in the same order as the circle of hues. The subtle and gradual contrast between the colors and hues creates an attractive harmony.

Here a gradation of purple and purple-blue hues is arranged to show the subtle contrast between the colors. A swatch of yellow adds contrast without upsetting the harmony.

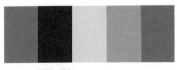

5Y/Gr 5Y/Lgr 5Y/Dl
 5Y/Dk 5Y/L

5P/Dgr 5PB/Dl 5P/Vp
 10PB/V 10PB/B

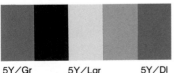

5PB/Dk

5Y/L

● Red

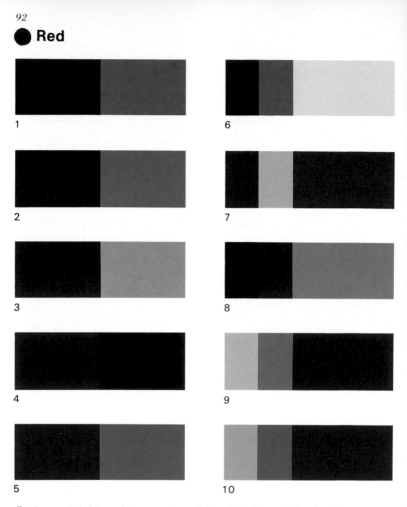

1

2

3

4

5

6

7

8

9

10

Reds are bright and warm, cheerful and inviting. Paired with various other colors, red can convey an exceptionally wide range of expression from hot to warm, elegant to outrageous, traditional to modern.

Colors within the red family go well together—as in 1, 2, and 3—for a cheerful and inviting mood at a luncheon when you use these colors to coordinate your tablecloths, napkins, flower arrangements, and tableware. Red and purple combine for a rich and elegant effect in 4, while red, pink, and gray in 9 are a smart-looking coordination to use for sportswear.

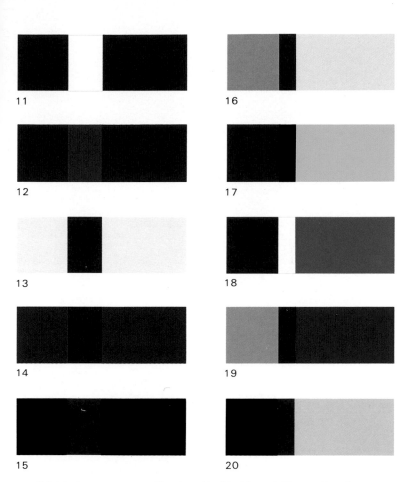

11 16

12 17

13 18

14 19

15 20

Bright, sharp contrasts like those in 11, 18, and 20 are attractive coordinations to use in clothing and interior decorating. Light gray, pink, and blue are soft and sweet, as in 13, 16, and 17.

See also DYNAMIC (pp. 74–77); ENERGETIC (pp. 62–65); especially (p. 77), 18; (p. 99), 19; (p. 123), 15, 20; (p. 125), 19; (p. 127), 18

● Orange

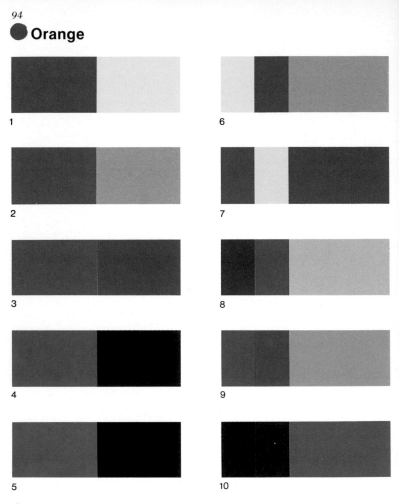

1

6

2

7

3

8

4

9

5

10

Orange is a color that brings to mind a happy, sunny outdoorsy feeling —a bright, cheerful color, full of life. Combine vivid oranges and yellows as in 1 and 6 for a brilliant coordination for beach or mountain wear and gear. A backyard barbecue or picnic is more fun when you use animated combinations such as in 2, 7, or 16.

A more subdued orange combination with brown and tan makes for an attractive living room, den, or bedroom, as in 3, 4, 8, and 9. Green adds a tropical flavor to 12, while 13 is a clean and refreshing combination for a summery outfit.

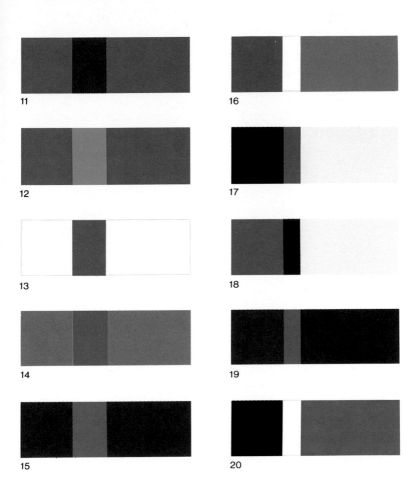

11

16

12

17

13

18

14

19

15

20

Package designs might make use of coordinations such as 17, 18, or even 20, or you can use them to wrap gifts or to color your own personal stationery.

See also DYNAMIC (pp. 74–77); ENERGETIC (pp. 62–65); especially (p. 65), 19; (p. 92), 2; (p. 101), 11; (p. 117), 16

Yellow

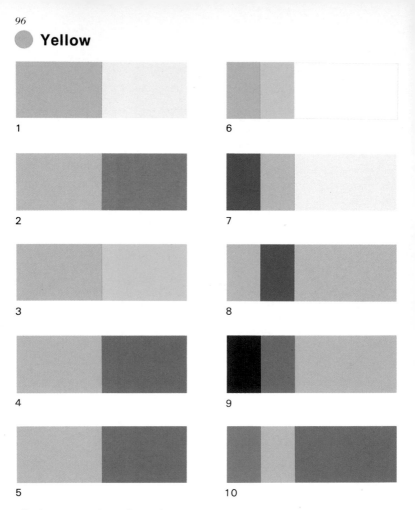

1

6

2

7

3

8

4

9

5

10

Perk up any color scheme by using a bright and sunny shade of yellow. Yellow can combine with other colors to make your kitchen come alive when you use it to paint or tile the walls and counters, as with 1, 2, 6, or 7. A light shade of green with yellow does well in the bathroom.

Fall fashions are animated with coordinations of yellow, olive, and brown, as in 4, 5, 8, 9, and 10. Use these colors in sweaters, mufflers, and knitted gloves to accent almost any outfit.

Achieve a stunning and youthful look by pairing yellow with dark or cool clear colors. Sports equipment and wear are more fun when col-

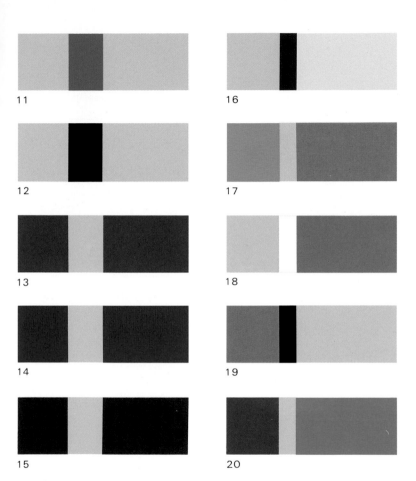

11

12

13

14

15

16

17

18

19

20

ored in combinations such as 11, 12, 13, 14, or 20. Enhance a picnic when you use color coordinations such as 17 and 18 or give a high-tech appeal to a room with black, gray, and yellow as in 19.

See also YOUTHFUL (pp. 10–13); ENERGETIC (pp. 62–65); DYNAMIC (pp. 74–77); (p. 13), 18; (p. 65), 19; (p. 93), 20; (p. 101), 14; (p. 105), 18; (p. 121), 17

● Green

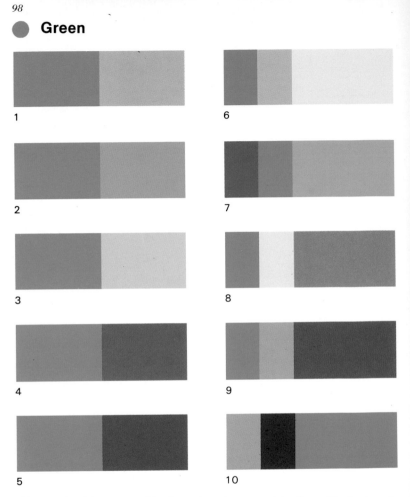

1

2

3

4

5

6

7

8

9

10

For a refreshing, natural feeling, almost any combination with shades of green fits the bill. Green helps erase the gray feeling of living in a big city by bringing nature into your home and wardrobe.

Choose a coordination of two or more shades of green for a fresh and cool summertime luncheon table, as in 1, 2, 3, and 6. Adding dark shades of green gives a more relaxed and restful feeling to a room, as in 5, 9, or 10.

Contrasting green with colors such as yellow, black, or white makes for bright, clear coordinations that go well with outdoor wear for the

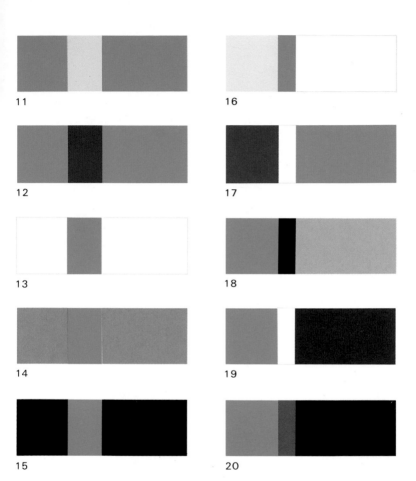

11 16
12 17
13 18
14 19
15 20

mountains or sportswear on the tennis court or by the pool, as in 11, 13, 15, or 16. Three-color combinations are especially attractive for young men's casual shirts, as in coordinations 17, 18, 19, or 20.

See also ENERGETIC (pp. 62–65); DYNAMIC (pp. 74–75)

● Blue

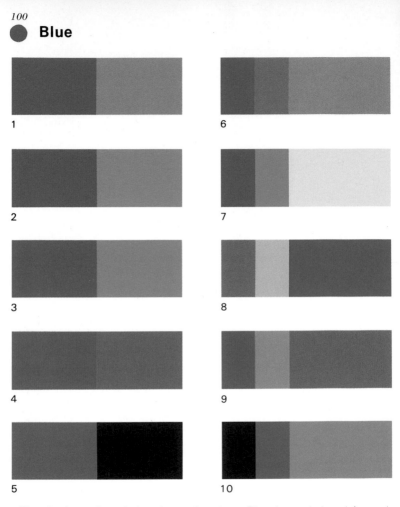

1

2

3

4

5

6

7

8

9

10

Blue is the color of the sky and waters. Blue is cool, bracing, and refreshing to look at in your home or in the clothes you wear.

Whether you coordinate light shades of blue—as in 1, 2, 3, or 4—or darker shades as in 5 and 10, the result is cool and sharp. In summer, use coordinations such as these for towels, sheets, pillowcases, and tablecloths to give your home a cool and refreshing appeal. Add gray for a sophisticated look in your wardrobe, as in 8 and 9.

Blue can be a cold, hard color. By matching blue with sharply contrasting colors, you can achieve a striking coordination to use with

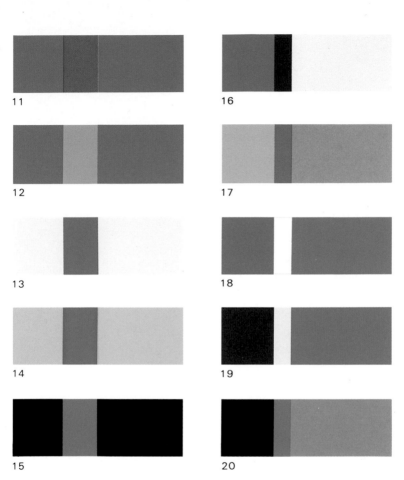

11
16
12
17
13
18
14
19
15
20

sportswear and equipment, as in 11, 12, 14, and 19. Softer, more sub-
dued coordinations can be seen in 13, 16, and 17.

See also YOUTHFUL (pp. 10–13); ENERGETIC (pp. 62–63); URBANE (pp. 18–21)

Turquoise

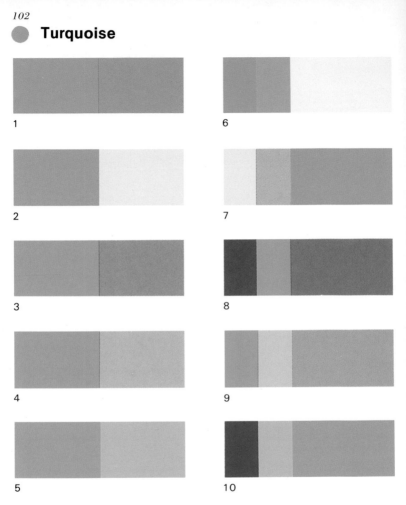

1

2

3

4

5

6

7

8

9

10

Turquoise is a sweet and clean color, which blends well with similar colors for a soft and somewhat feminine appeal.

Lighter shades combine in 2, 4, and 5 for a refreshing look, while the delightful aroma of limes seems to linger in kitchens decorated in combinations 6 and 10. Lavender and turquoise are soft and very feminine schemes for decorating bedrooms and bathrooms, as in 3, 4, 7, and 8.

White and black pair with turquoise for an art deco look in 11 and 12, while yellow, pink, and purple are sweet and delicious in 13, 14, and 15.

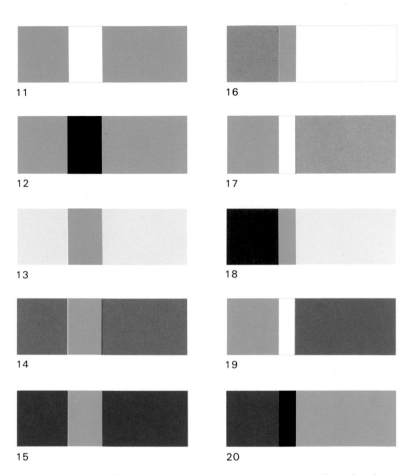

11

16

12

17

13

18

14

19

15

20

Three-color coordinations make for attractive tennis, golf, or jogging wear, in 16, 17, and 19.

See also FRESH (pp. 6–9); YOUTHFUL (pp. 10–13); SWEET (pp. 54–57)

Saxon Blue

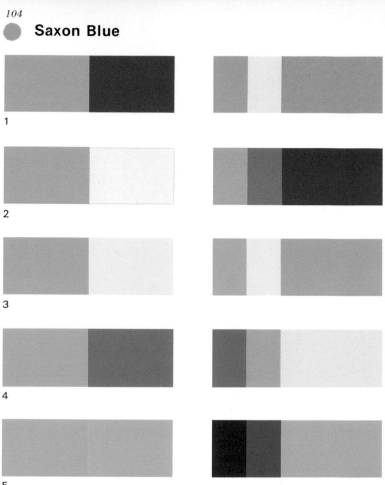

1

2

3

4

5

Saxon blue can be categorized as lying between sky blue and aqua blue. Saxon blue is very clear and clean. It can be used for fabric for almost any purpose from clothing to furniture, linen, or drapes.

In the home, coordinations that pair saxon blue with another similar shade are especially attractive when used with curtains, tablecloths and napkins, aprons, and drapes, as in 3, 5, 6, 8, and 9. Use these coordinations to give your home the feeling of a clear, sunny summer morning.

By sandwiching a contrasting color between two segments of saxon blue or by surrounding it with a strong contrasting color, you can bring

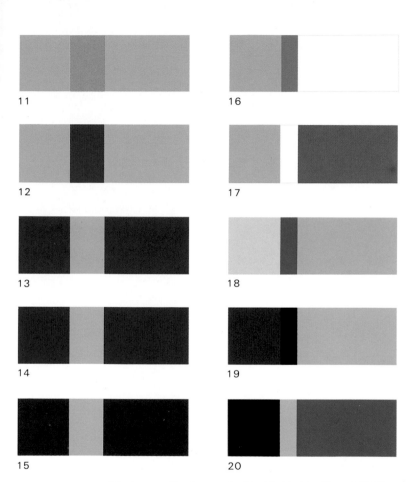

11

12

13

14

15

16

17

18

19

20

out a sporty and lively coordination, as in 11, 12, 13, 14, 15, and 19. You can even try these coordinations out on your private stationery or party invitations. Use cheerful three-color coordinations in your wardrobe, like those in 16, 17, 18, and 20.

See also FRESH (pp. 6–9); YOUTHFUL (pp. 10–13)

Ivory

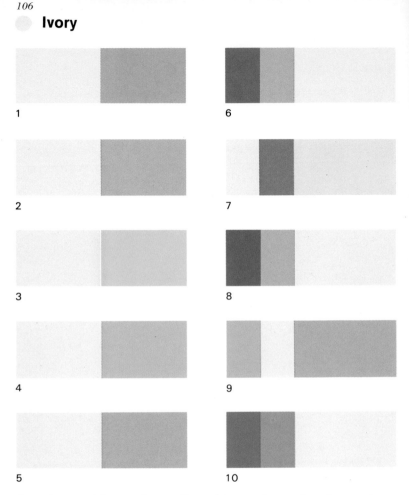

1

2

3

4

5

6

7

8

9

10

Ivory is one of the most versatile and harmonious colors. Ivory sets a naturally soft and pleasant mood whether used for decorating your home or coordinating your wardrobe.

Use ivory in combination with other quiet tones for a soothing and relaxed feeling in bedrooms, living rooms, and dens, as in 1, 2, 5, 6, and 7. Adding green to the coordination gives it a natural appearance, as in 3, 4, and 10.

Ivory combines with contrasting colors for a mellow, harmonious effect. Combine ivory with browns as in 11, 12, and 16 when coordinating

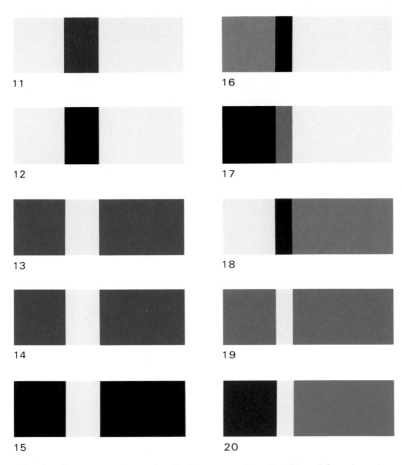

11

12

13

14

15

16

17

18

19

20

the furniture, carpets, and walls in a room for a traditional American interior. Orange and blue combine with ivory for a sharp modern look for your home.

Three-color combinations such as 16, 17, 18, and 19 are tasteful ideas for coordinating your wardrobe.

See also BREEZY (p. 61); SWEET (pp. 54–57); ARCADIAN (pp. 34–37)

● Pink

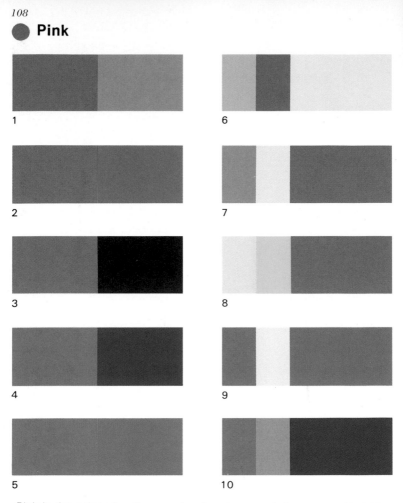

1

2

3

4

5

6

7

8

9

10

Pink is the color of cotton candy, cherubs, sweet dreams, and bubble gum. Coordinate pink with other shades of pink or purple to keep this image.

Pink combined with a slightly darker color makes for a more mature coordination, as in 3, 4, and 10. Lavender is graceful with pink in 2 and 9, while light chartreuse gives a cute appeal to 8. Try these color coordinations when embroidering a sweater or blouse.

For bright and colorful coordinations using pink, avoid using colors

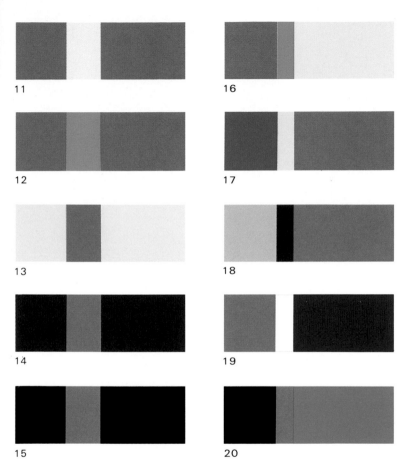

11

16

12

17

13

18

14

19

15

20

that are too bright or strong, for they tend to overwhelm rather than compliment the more tender pink.

Cool blues in 12 and 13 are fine for colorful summer wear, while black contrasts well for sharp-looking sportswear in 15 and 20.

See also SWEET (pp. 54–57); DREAMY (pp. 50–53)

● Lavender

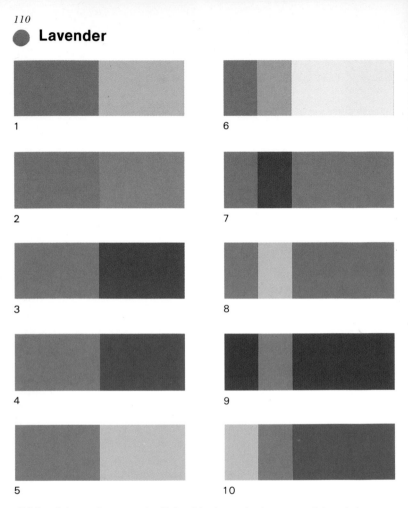

1

2

3

4

5

6

7

8

9

10

While pink may be more for little girls, lavender is a graceful and elegant color for women. Lavender is a charming and attractive color for fashion or interior decorating.

Pink is a natural partner for a soft and feminine touch, as in 1, 2, 3, 6, 7, and 9. Purple adds a sophisticated touch, as in 4, 5, and 10, while a light muddy olive lends a youthful note to 8.

Contrast lavender with other colors for a sharp and fashionable look. Peppermint green works well for a cheerful springtime outfit, as in 11 and 16. Ivory and lavender are just the right coordination for your

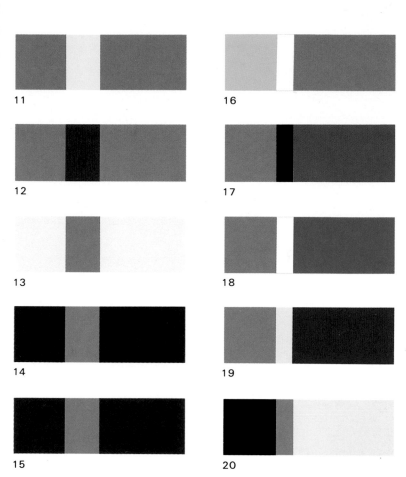

11

16

12

17

13

18

14

19

15

20

bedroom, as in 13. The blues in 18 and 19 make an attractive combinations to use in a women's casual suit.

See also TENDER (pp. 42–45); ALLURING (pp. 46–49); COOL (pp. 14–15); DREAMY (pp. 50–53)

● Beige

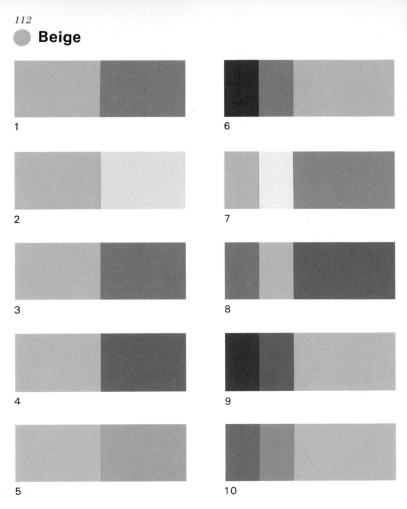

1

6

2

7

3

8

4

9

5

10

Beige is a solid, dependable color for your wardrobe or interior decorating schemes. Being a relatively calm and relaxing color, beige goes well with subdued oranges and yellows as well as various shades of brown.

Combinations 1 through 5 are attractive suggestions for coordinating the walls and carpets in your home, while the light and dark grays and beige in 7 and 9 give a modern, up-to-date look to furnishings. The warm tones in 6 and 8 provide an inviting appeal to your living room or den.

Use strong and rich tones with beige for a mature but stylish accent in

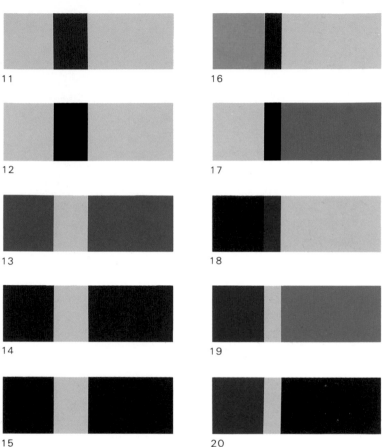

your wardrobe. Thirteen, 14, 15, and 20 have a nostalgic air about them, while 11 and 12 are crisp and fresh. Eighteen has a feminine touch, but 19 is more masculine in nature.

See also ARCADIAN (pp. 34–37); BREEZY (pp. 58–61)

● Brown

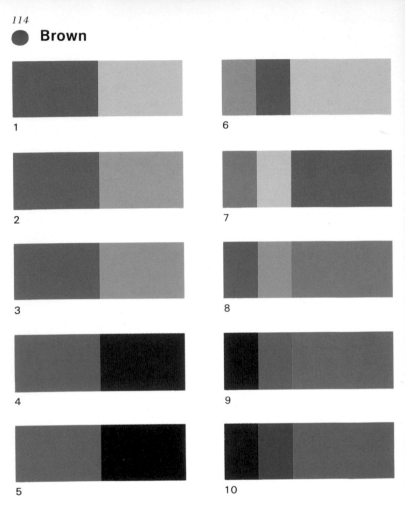

1

6

2

7

3

8

4

9

5

10

Brown is a hearty and honest color, rich but not ostentatious. Use brown to give your home a warm and inviting feeling and in your wardrobe in autumn and winter for a simple but stylish appeal.

Coordinations using lighter shades of brown, as in 1, 2, 3, and 6, should be used to color walls and floors in the home, while the slightly darker combinations in 7 and 8 are a good choice for carpets, curtains, and furniture fabrics. Yet darker coordinations, as in 4, 5, 9, and 10, give a room a traditional air that goes well with antique furniture.

Use brown as a base to build a man's wardrobe, combining it with

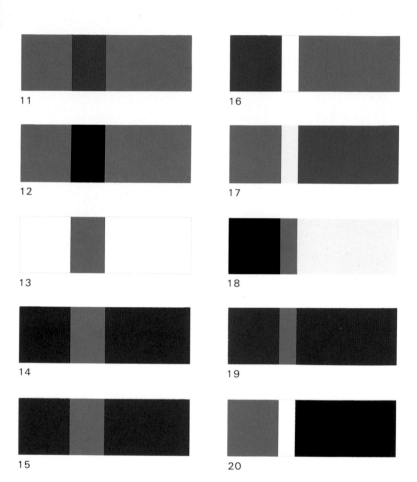

11

16

12

17

13

18

14

19

15

20

such colors as white, deep purple, gray, green, and red for a smart and strong appeal, as in 11, 13, 14, 16, 17, 18, and 19.

See also EARTHY (pp. 30–33); MATURE (pp. 26–29); ARCADIAN (pp. 34–37); (p. 127), 17

● Olive

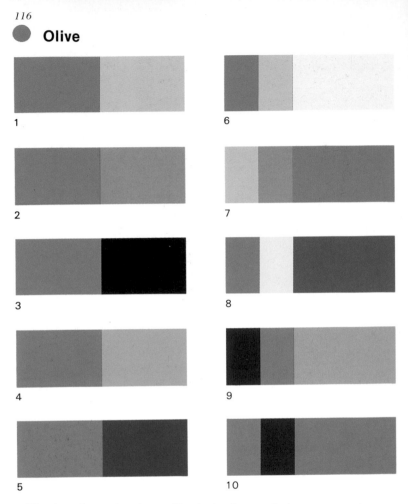

1

2

3

4

5

6

7

8

9

10

Olive is a pleasant and versatile shade of green that you can use in your wardrobe or home. When you combine it with various shades of light brown, the effect creates a natural harmony perfect for spring and summer fashions, as in 1, 2, 6, and 7. A splash of yellow in 8 makes for a light-hearted combination to use in putting together an outfit for a picnic or backyard party.

For a more conservative and subdued contrast, pair together olive and gray as in 5 and 10. Or for a brighter and youthful combination, red, orange, and blue do the trick, as in 12, 16, and 17. For a clean, modern

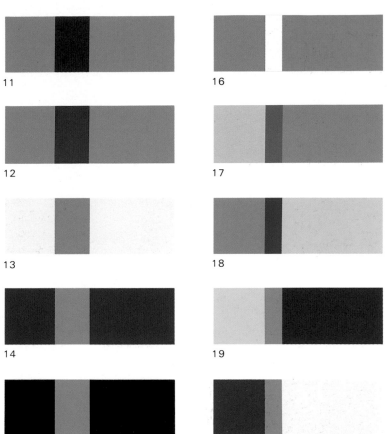

11

16

12

17

13

18

14

19

15

20

look for home or office, try matching olive with a contrasting light and dark color, as in 19 and 20. Be careful, however, to avoid colors that are too bright, for they will overwhelm the subdued olive.

See also EARTHY (pp. 30–33); ARCADIAN (pp. 34–37)

● Wine

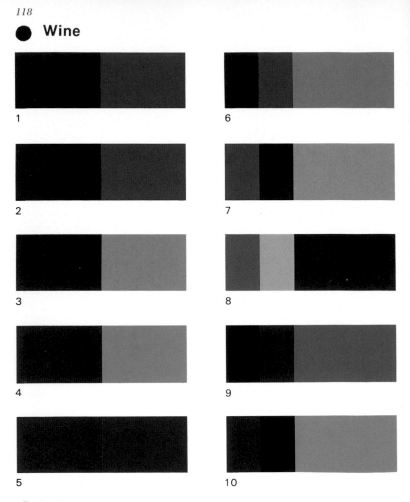

1

2

3

4

5

6

7

8

9

10

For both men and women, wine is a rich, elegant, and velvety color that brings a sense of class and style to any wardrobe.

For women, wine paired with lighter shades of red and pink—as in 1, 2, 3, 6, and 7—results in coordinations that are very feminine. Combinations like those in 5, 8, and 9 are more reserved and can be used for dresses for parties or other social occasions.

Combining wine and gray, as in 4, 10 and 13, creates a mature, no-nonsense image in suits for men and women. Wine is a smart addition to

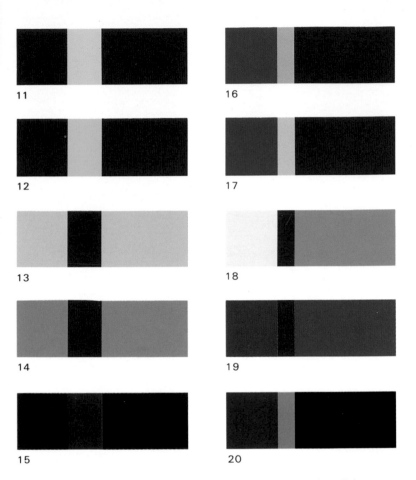

11

16

12

17

13

18

14

19

15

20

a man's casual wardrobe when combined with colors such as light gray, blue-gray, and ivory as in 17 and 18.

See also LUXURIOUS (pp. 66–69)

● Dark Blue

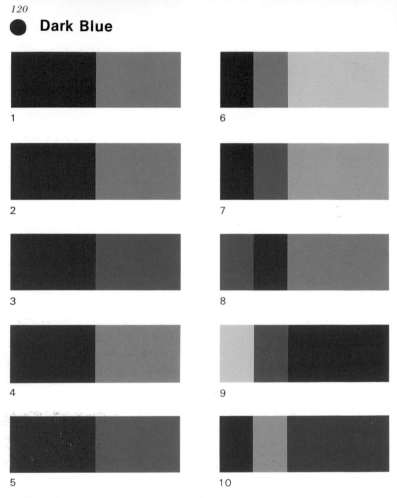

1

2

3

4

5

6

7

8

9

10

Although sometimes dismissed as being too stodgy and conservative, dark blue is a very versatile color to use in your wardrobe and home.

Combine dark blue with other lighter shades of blue for subtle contrasts to use with suits for men and women, as in 1–5. A smaller proportion of dark blue matched with various shades of gray and blue makes for understated but sophisticated casual coordinations for fall and winter fashions in 6, 7, and 8.

Bright, contrasting colors combine with dark blue for a sharp and modern look. Use white for a sporty contrast to wear in spring and sum-

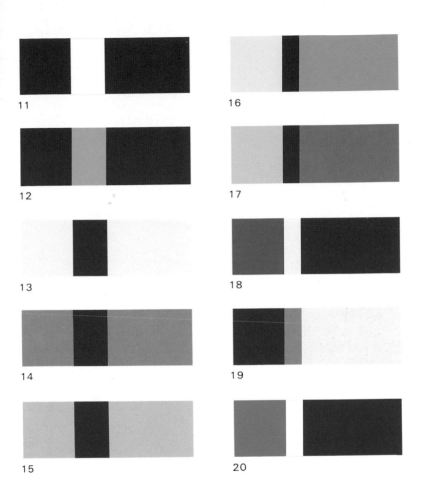

11

12

13

14

15

16

17

18

19

20

mer, as in 11 and 20. Orange, yellow, and red can combine with dark blue for coordinations for spring and summer casual wear or to decorate your home, as in 12, 17, and 18.

See also RESOLUTE (pp. 22–25); MATURE (pp. 26–29); DYNAMIC (pp. 74–77)

White

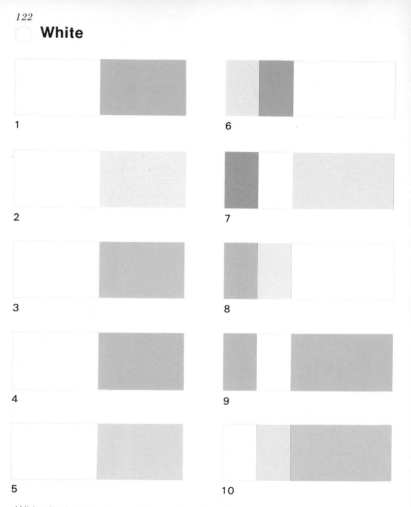

White is the most versatile of all colors. It has the ability to change the mood of almost any coordination to make it lighter, softer, brighter, or more vivid.

Use white with soft pastels to create coordinations for a summer party dress, as in 8 or 9, or for a understated tone in interior furnishings as in 3 and 5. Shades of blue with white, as in 1 and 6, are an attractive coordination to use in tiling a bathroom or kitchen.

Bright colors become vivid colors when paired with white, as in 11–15. Use coordinations such as these for sportswear and equipment or for

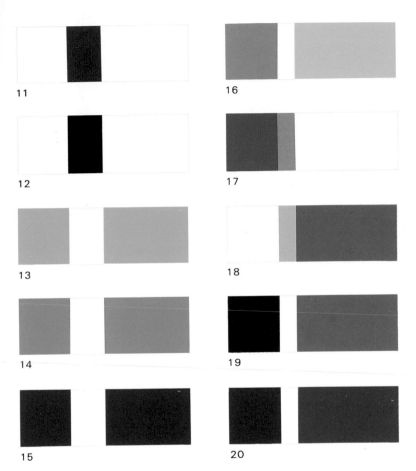

11
12
13
14
15
16
17
18
19
20

outdoor furniture for a cheerful and modern appeal. Three-color coordinations such as those in 16–20 are perfect for outdoor summer parties and outings.

See also Urbane (pp. 18–21); Fresh (pp. 6–9); Youthful (pp. 10–13); Dreamy (pp. 50–53); Sweet (pp. 54–57); Energetic (pp. 62–65); especially (p. 9), 18, 19; (p. 53), 19; (p. 65), 18

● Gray

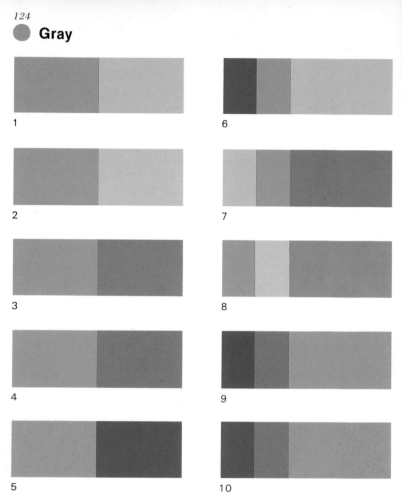

1

2

3

4

5

6

7

8

9

10

Gray has properties similar to white. It can be soft when paired with pastel colors or it can enhance vivid colors when placed next to them.

Pastel tones of blue, lavender, pink, and green are soft and feminine when paired with a light gray, as in 1–8. Use coordinations such as these for matching skirts and sweaters, or suits, shirts, and ties for women. Men should wear slightly stronger pastels, as in 6, 9, and 10.

For chic and modern combinations to use in office interiors or reception areas, pair gray and a cheerful shade of purple, red, brown or blue,

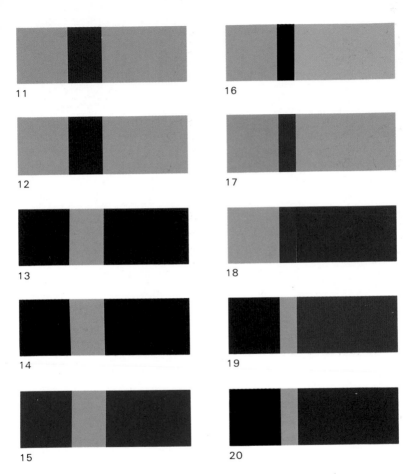

as in 12, 13, 14, and 15. Gray also makes attractive casual wear coordinations for men and women, as in 16–20.

See also SENSIBLE (pp. 38–41); COOL (pp. 14–17); RESOLUTE (pp. 22–25); MATURE (pp. 26–29); TENDER (pp. 42–45)

● Black

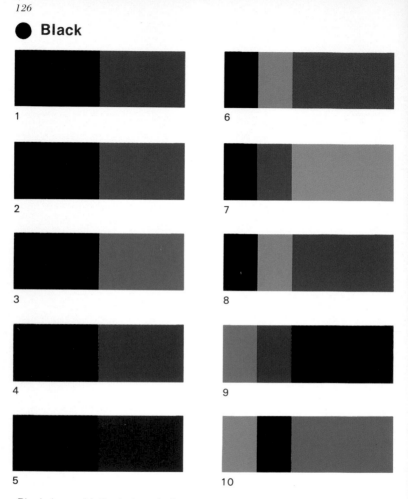

Black is sophisticated and elegant, strong and versatile, formal and mournful. Black is also a mandatory color for men's and women's wardrobes.

Pair black with other dark colors for a rich combination to use in coordinating outfits with sweaters, shirts, pants, and shoes in winter. Deep shades of blue, green, and red work especially well, as in 1, 2, and 5. Black with dark and light shades—as in 6, 7, 8, and 10—combine well for a sophisticated look when coordinating interior furnishings and colors.

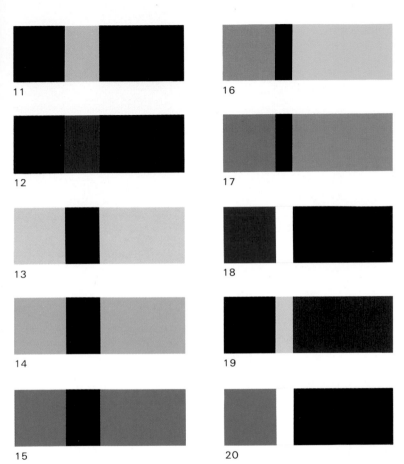

11 16
12 17
13 18
14 19
15 20

Use black to intensify bright colors for combinations to use in everything from a modern interior to sportswear for aerobic dancing and bicycling to table settings for a dinner party. Examples include 11, 12, 14, 15, 16, 18, and 20.

See also Urbane (pp. 18–21); Resolute (pp. 22–25); Mature (pp. 26–29); Dynamic (pp. 74–77); Folksy (pp. 70–73); Luxurious (pp. 66–69); especially (p. 21), 18, 19; (p. 77), 19

Shigenobu Kobayashi

Shigenobu Kobayashi (b. 1925) is the founder and director of the Nippon Color & Design Research Institute. He is a graduate of the electronics department of the Hiroshima College of Technology and received a master's degree from Waseda University in Tokyo for his work in the field of color psychology.

Since founding the institute in 1966, he has been a leader in research on color psychology, publishing numerous books on the subject, including a color image dictionary and others exploring color in relation to design, architecture, and the environment. A detailed discussion of his theories is available in English in the publication *Color Research and Application* (volume 6, no. 2, Summer 1981) in an article titled "The Aim and Method of the Color Image Scale."

He is also an active participant in meetings of the International Color Association and a lecturer at the Musashi Institute of Technology in Tokyo.

The Nippon Color & Design Research Institute

Founded in 1966, the Nippon Color & Design Research Institute is a leader in its field, acting as a color and design consultant to over 300 major Japanese corporations in fields as diverse as automobiles, home electronics, cosmetics, food, department stores, and home construction.

The institute's patented Color Image Scale is the centerpiece of its theories on the psychology of color. In addition, the institute has developed computer software based on the Image Scale and a large information data base for use in its research and consulting projects.

Address: 8–22, Ichigaya Dai-machi, Shinjuku-ku, Tokyo 162